PARANORMAL
DERBYSHIRE

PARANORMAL
DERBYSHIRE

JILL ARMITAGE

AMBERLEY

First published 2010

Amberley Publishing Plc
Cirencester Road, Chalford,
Stroud, Gloucestershire, GL6 8PE

www.amberleybooks.com

Copyright © Jill Armitage, 2010

The right of Jill Armitage to be identified as the Author
of this work has been asserted in accordance with the
Copyrights, Designs and Patents Act 1988.

British Library Cataloguing in Publication Data.
A catalogue record for this book is available from the British Library.

ISBN 978 1 4456 0081 9
Typesetting and Origination by Amberley Publishing.
Printed in Great Britain.

Contents

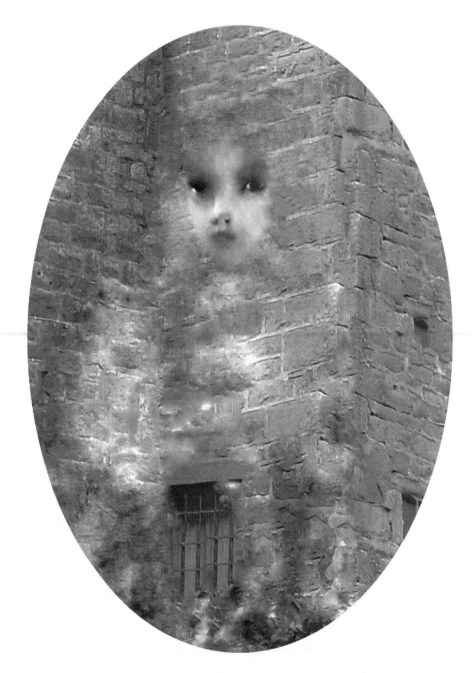

A ghostly vision

Introduction

I am not likely to forget Puzzle Gardens in Wirksworth. This is the area where the old lead miners lived in their jumble of tiny cottages that cling to the steep hillside linked by a maze of muddled footpaths. It's the lack of planning behind the higgledy-piggledy collection of properties that has given it the name but it left me with a paranormal puzzle after asking one of the residents if her home was haunted. She looked unsure. 'What do you mean by haunted?' she asked.

Surprisingly this is not a silly question. Hauntings don't have to be theatrical. Very few sightings feature some ghostly spectre in white that drifts noiselessly across the floor, or dramatic scenarios where objects fly across a room as if thrown by an invisible hand. While popular representations of the paranormal include such phenomena as hauntings, poltergeists and UFOs, most activity is rather less exotic. It's more likely to be a number of odd but benign occurrences that leave you feeling puzzled.

'Do you ever sense that your home is being inhabited by some mischievous, anti-social or highly inquisitive spirit?' I enquired.

Having thought about it for a minute, she then told me about a time when the lights went off but the switch was still in the 'on' position. I wasn't sure whether this was a genuine case of spirit activity or a blown fuse, but at least we were on the right track. 'There's a corner of the sitting room that often feels cold,' she continued. 'And whenever I put a plant in that corner, next morning it has always drooped and within three days all the leaves had turned a sickly brown. Could this be blamed on spirit intervention or is it because I don't have green fingers?'

These might seem like minor incidents yet electrical malfunctions and cold spots are regularly experienced in the paranormal; less frequently reported is the surprising effect it has on plant life, but it's an established fact. Whether it's through spirit intervention or the power of the human mind, (known as bio psychokinesis) it is alleged that it's possible to kill a plant simply by staring at it. On the plus side, Uri Geller (remember those bending spoons) claims able to make seeds germinate using only the power of his mind. In demonstrations, he empties a packet of seed into his hand and after concentrating on the seeds, he opens his hand to reveal that some of the seeds have sprouted.

This is what the paranormal is all about. It's a mysterious, intriguing, awe inspiring and exciting facet of human life that common sense simply can't justify or explain. More and more people are becoming aware that things beyond the current range of scientific explanation or normal human capabilities can and do happen. I add the word current because it could be just a matter of time before the paranormal becomes the normal. Who knows! It's a mystery puzzle made up of many parts, so come with us and delve into the paranormal secrets of Derbyshire.

Jill Armitage
2010

Is it a Haunting or a Hallucination?

Many people believe they have seen a ghost. The experience is as old as records of civilisation, but if there really are such things, they challenge all established views and ideas. Science doesn't like that! It has a problem dealing with things that can't be explained so scientists have come up with the idea that ghosts are purely hallucinatory – a word that comes from a Greek term meaning *'to wander in the mind – a sensory perception that has no external cause, when a person can be taken out of normal reality into a different realm.'* In other words, 'if' you see a ghost scientists reason that you must be imagining it!

Illness, drugs, exhaustion or sleep deprivation can produce hallucinations, causing a person to enter an altered state of consciousness. This can produce a misperception rather like a mirage seen by travellers who become lost and disorientated through lack of water. But it's not just sight which is called visual hallucination, there's smell – olfactory hallucination, and hearing – auditory hallucination. Less well documented is taste – gustatory hallucination, and touch – tactile hallucination. In addition, hallucinations can also affect the judgement of size, and is known as dimensional hallucination.

So are ghosts really caused by hallucination? We set off to find out.

VISUAL HALLUCINATIONS OR SPECTRES WE CAN SEE

Seeing a ghost is high on most people list of how ghosts actually 'appear' to us. I'm often asked if I've seen a ghost; I've never been asked if I've heard one or smelt one but it's just as likely, because they can be perceived by each of our five senses individually or in combination – even if they are hallucinatory.

Monotonous motorway driving must be the number one cause of hallucinations, so could that be the reason behind our first story? Judge for yourself.

Motorway Madness
Cutting through the hills and across the coalfields between Pinxton and Barlborough is the 14 ½ mile Derbyshire stretch of the M1 motorway. 23 August 1965 saw the

start of this £12,000,000 contract that met problems right away. It started with bad weather conditions and major subsidence associated with an area riddled with old mine shafts, many uncharted. Soon some 800 magnetic anomalies in the soil formation were discovered. Magnetic anomalies are the result of variations in the magnetic properties of rock types, and when the pattern is disturbed or distorted, it causes localised magnetic effects. Sailors are aware of this because for no apparent reason their compasses become inaccurate. Think Bermuda Triangle and you get the idea. So is it possible that modern cars that rely heavily upon electronic gadgetry could also be influenced when they drive through such an area?

Within a decade of the opening of the M1 motorway there had been so many horrendous accidents that the press were investigating whether this was something more than drivers travelling too close, too fast and without due care and attention. People began to report strange phenomena, and the motorway became directly associated in the popular imagination with hauntings. A haunting is a repeated observation of an apparition by different people at different times in the same place.

In March 1978, the *Derbyshire Times* ran the story that a stretch of the M1 at Pinxton had more than its fair share of accidents. This section is often fog bound when no other is, claimed the paper, but is this a natural fog? Suggestions have been made that the motorway crosses the direct path where a ghost is said to walk, but this implication has been met with ridicule. Although it's become the most widely accepted cause for such speculation, people say that such things are caused by hallucinations due to monotonous driving conditions.

Or is it possible that the magnetic anomalies are causing the problems? It is not unusual for a site where such anomalies are present to acquire a mysterious quality. It has been suggested that this is the site of a giant meteorite strike, or a secret observatory or tracking station by extraterrestrials, so if you are driving along this stretch, watch out!

Country Lane Confusion
Dark, country lanes illuminated only by car headlights can also produce monotonous visual stimuli.

In the 1970s the father of a young Grindleford businessman told of his son's experience when driving along the road from Eyam to Grindleford. He had returned home shaken and upset. On the bend above Jacob's Ladder, an old bridle-road climbing steeply from Stoney Middleton, he had stopped his car in stunned amazement to watch an indistinct figure shrouded in cloak and hood, cross the road and pass through the solid stone wall to proceed up the old cart-track in the direction of the disused Riley slate-pits. Shocked and dazed by the experience, he sat at the wheel for some time before recovering enough composure to resume his journey.

What he had seen was not an indistinct misty shape, a formless wraith or insubstantial spirit image wreathed in a shroud-like astral attire. It had the appearance of physical solidity, clothed in garments which had a realistic quality; the type of attire that would have been worn by the phantom during the days of her mortality.

Watch out!

Replayed Road Accidents can be Seen ...
It was 8.05 on 4 November 2006. A man was leaving Spondon, driving along Morley Road approaching Smalley crossroads, and as the traffic lights changed to red, he pulled to a halt. As he waited patiently staring at the road ahead, he saw the outline of a motorbike lying in the middle of the road, then the ghost of a man wearing a crash helmet got up from the road and walked towards the pavement near the motorbike shop on the corner. As he walked, the driver could see straight through him. When the lights changed he drove straight over the ghostly motorcycle and the air in the car had a real chill.

... and Felt
One night, a police dog-handler was driving along the road heading towards Pilsley when a figure appeared in the full beam of the headlights. Although the officer braked furiously he couldn't avoid hitting him head on. The man bounced over the bonnet and fell. In a state of shock, the officer grabbed a torch and leapt out of his van. He released his dog who jumped out, howled pitifully and shot off down the road.

The officer searched the roadside looking for the accident victim but there was no-one and the hedge was undisturbed. He checked the front of the vehicle for signs of the impact, but could see nothing. He got back inside the van and proceeded slowly down the road just to make sure the injured person hadn't somehow stumbled away from the scene of the accident. As he drove he realised that although he had seen the impact he hadn't felt it or heard it.

At first light, he returned to the scene of the accident but could find no trace of anything strange. Back at the police station, he began to explain what had happened but the Sergeant stopped him. 'Don't worry about it,' he said. 'A man was killed at that spot many years ago and the replay is witnessed regularly.'

Did You See That Too?
The theory of hallucination becomes even less satisfactory in situations where there are a number of witnesses all seeing the same apparition at the same time, or a number of independent witnesses seeing the same apparition over a period of time. That's called a collective apparition.

If evidence of a psychic phenomena is based on only one person's account, there might be grounds for sceptical suspicion, but when two or more people witness the same manifestation and others have reported the same thing, this theory fails miserably.

The Phantom Cyclist
Many motorists have reported the sightings of the phantom cyclist travelling along Dale Road, Spondon. One incident happened as a couple who had just had a meal at Bartlewood Lodge were heading home towards Stanley Common. It was raining heavily and the windscreen wipers were working overtime, and in front was a cyclist dressed in cream trousers, a blue jumper and white flat cap – summer wear that gave no protection from the persistent rain. After rounding the bend the cyclist was riding a few yards in front and they considered it was safe to overtake, but as they drew parallel they realised they could see straight through him and his bike. As they stared in disbelief the cyclist and his bike began to dissolve until they were looking through a bluish see-through haze.

The Phantom Hitch Hiker
It was a cold winter night and a young courting couple were riding a motorbike and sidecar along the road between Fox House and Sheffield when they stopped to offer a lift to a hitch hiker who seemed in distress. She was obviously a biker, dressed in motorcycling leathers and a crash helmet, but apart from giving a Sheffield address, she said nothing. She climbed onto the pillion seat and they set off.

They hadn't gone very far when to their horror, the couple realised that the girl biker had disappeared. Totally mystified, they retraced their route back to Fox House, but the girl had simply vanished. They were so shaken, they reported the incident to the police then decided to go to the address given them by the girl.

The door was opened by a middle aged woman and the couple tried to explain in a rather apologetic manner what had happened. The woman burst into tears. The description of the hitch hiker fitted perfectly that of their daughter who had been killed in a recent motor-bike accident on the very spot where the couple had first seen her.

The Ghost of Spend Lane
So many accidents have happened on Spend Lane, north of Ashbourne that it is known as an accident black spot, but many believe the lane to be haunted.

Harold Maddock was driving along Spend Lane one fine, dry November night in 1977 on his way to collect his wife and son from the Dog and Partridge. It was about 10 o'clock and all the windows were closed yet suddenly the car was full of a rushing wind that Harold described as 'one hell of a gale'. It roared loudly and sounded as if the upholstery was being torn, then he felt a sudden blow in his stomach. He instinctively raised his arm to ward off whatever it was yet there was nothing to be seen. The whole incident lasted no longer than a few seconds, yet Harold drove to the Dog and Partridge in a state of shock. There, he and his family checked the car and despite the sound of ripping upholstery, the seats were untouched and there was not a mark on the car, inside or out. The next morning giving the car a thorough search, Harold found a 1 ½" metal disc that had previously been attached to the dashboard on the floor. This could have been what hit him in the stomach but what had caused it to break loose and hit him with such force?

The local papers regularly report accidents occurring on Spend Lane, usually blamed on drivers losing control on the bends or driving too fast, yet it's not just drivers. Riders have been thrown by normally well-behaved horses that suddenly turn skittish. Horses, like the dog in the previous story are very susceptible to spirit, so this could be a good indication that the lane is haunted. Locals will tell you the tragic story of a bride travelling along Spend Lane from Fenny Bentley to her wedding in Ashbourne, when the carriage turned over and she was killed. Could this incident have left a ghostly legacy on Spend Lane?

The High Peak Carter Haunts the Bamford Road

Imagine the surprise of people driving along the A57 where it meets the A6013 from Bamford, who have to slow down behind a carter and his horse. This is a true country rustic, the type you would meet regularly in this area one hundred plus years ago when this wild, inhospitable country was inhabited by lead miners and hill farmers. The carter is described as wearing a tall hat, knee length smock and carrying a long riding whip as he walks along at a steady pace leading a horse and a strange cart with high sides, but as you blink in disbelief he disappears.

Phantom Coaches

Residual energy from the stagecoach era of the past is regularly experienced today throughout Derbyshire.

The road which runs between Youlgreave and Middleton has a phantom coach and horses lit by ghostly lamps and accompanied by ghostly dogs. If you travel along the Bakewell to Hassop road, watch out for the phantom cavalier who steps out into the road in front of vehicles, or the phantom coach and horses that is likely to overtake you. Many motorists who have encountered them suffer from shock, and apparently one died after swerving to avoid crashing into a coach and horses crossing his path Traumatised people who have witnessed these strange phenomena call in the Eyre Arms in Hassop to tell their stories, and they all bear a striking similarity.

A Brassington postman was just returning through the fields from one isolated farm when he saw a coach and horses coming up the road from the direction of Ashbourne.

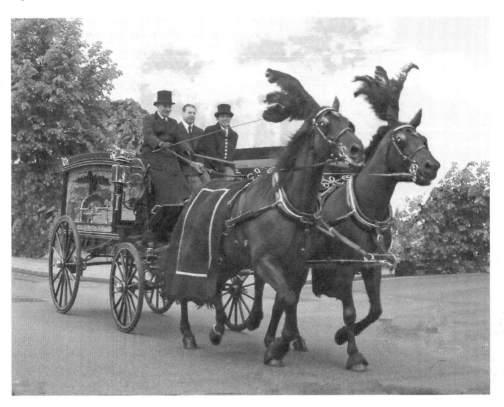

A funeral coach

The coach was brilliantly illuminated and the postman had never seen such a vehicle before, but as it was heading in the general direction he was going, he decided to thumb a lift. He shouted and waved his arms to attract attention as he ran towards the Holly Bush-Bentley road intent upon intercepting it, but suddenly the coach was just no longer there. It had completely vanished.

Three young girls saw a vision near St Mary's Chapel by the river at Duffield/ Little Eaton. They described it as looking like an old-fashioned funeral party. There was a large black coach pulled by black horses with black plumes on their heads. Relating their experience which they found rather scary, the parents got in touch with the local vicar to see if an old fashioned style funeral had taken place that day. They were assured it hadn't. They even made enquiries to see if any period film was being shot there that day but again found the answer to be no. So had the girls experienced some kind of hallucination or was it a time slip and they had viewed a funeral that had taken place at some other time in history?

Phantom coaches seen prior to a death in the family are known as death coaches. They are customarily black, pulled by headless black horses and driven at a furious pace. The driver usually has skeletal or grotesque features and they are believed to forewarn of a death in the family or alternatively it is said that anyone who gets in the way of a phantom coach will be carried away to their own doom!

The vision of a beautiful royal carriage and horses is seen travelling very slowly over the old bridge at Derby. Inside the carriage sits a young woman who is sometimes described as completely oblivious to outside influences, although on other occasions she is said to be looking from left to right. As the carriage reaches the far side of the river it disappears without trace. A bridge has spanned the river here since at least the thirteenth century, and the present bridge was built in 1794. Many people believe that this woman is Mary Queen of Scots re-enacting her last fateful journey. She spent her final night in Derbyshire at the Derby home of Babington, ironically the family home of the man who was responsible for her death.

Four Women Saw the Ghost

A combination of isolation, tiredness and monotonous visual stimuli can cause hallucination, but how do you account for an incident that was witnessed by four women travelling in one car? Put four women together in the confined space of a car and you can certainly rule out isolation, tiredness and tedium. There is also the fact that all four women saw it, so that rules out the theory that a ghost exists only in the mind of the person experiencing it. When more than one person experiences the same unexplainable occurrence, it proves that strange happenings are not hallucinations or the product of one person's imagination.

One evening in March, a car containing four women was travelling on the B6036 between Ashover and Woolley Moor. It was about 8.00 p.m. The night was dark and visibility poor on the unlit country road, but on the stretch overlooking Ogston reservoir, they encountered a small, headless figure, dressed in an off-white smock. There was only the outline of a head and it was waving its arms around disjointedly. The car's occupants panicked and drove off, although they later returned but saw nothing.

This story was given to Clarence Daniel, the Eyam antiquarian and ghost hunter by Dylis Twyford after he had given a talk on ghosts to Birchover WI. Clarence wrote to her to confirm the details and this is her reply.

Dear Mr Daniel

Thank you for your letter received yesterday, which I found very interesting. I and my three friends, who also saw the ghost as we were all travelling together are extremely pleased that you have taken an interest in our experience and I personally, will do my best to give you as precise details as possible.

The date on which we actually saw the ghost was Tuesday 14th March at about 8.20 p.m. It was quite small, about the size of a child, and was dressed in an off-white smock. We couldn't see a head – just the outline and at that point it seemed to get quite clear and was waving its arms in an uncanny manner (it was as if it didn't have any joints)! I am afraid that we panicked at this point and drove off, and although we passed back that way about half an hour later, there wasn't a sign of anything having been there. We went up the following night in daylight and made some enquiries. You probably think this sounds utterly ridiculous, but I can assure you that it did happen and we all four saw the spectre. I have also

learnt that another lady saw the ghost quite a number of years ago in almost the same spot.

Yours sincerely

Dilys M. Twyford (Miss)

TACTILE HALLUCINATION OR PUSHY POLTERGEIST

The previous stories are about seeing ghosts, but possibly the most scary thing is feeling them. People have been touched, tapped, squeezed, pulled, pushed, punched, pinched, kissed and strangled. Can we discount such things as tactile hallucinations?

The Pushy Ghost

The Courtyard in Chesterfield used to be an old schoolhouse, later it was converted into shops and more recently a lounge bar called The Loft Bar run by Phillip Richardson Wood. One day while concentrating on a pile of paper work, Philip was given a violent push which sent him sprawling over his desk. He whirled round to confront his attacker, but found that he was quite alone. Until then he might have blamed the wind for the strange noises that often sounded remarkably like footsteps walking across the floor, and the peculiarities of an old building that made the cellar door bang closed. But what caused the furniture to move, the tinkling of glasses and the feeling of being poked? These are just some of the strange happenings that people have encountered in this building.

The Kissing Ghost

Renishaw Hall has been the Derbyshire seat of the Sitwell family for over 350 years and its paranormal activity is so strong, that the 'Duke's Landing' on the first floor has been dubbed by the family 'Ghost Passage'.

'I've never seen them, but they can worry the guests,' said the late Sir Reresby Sitwell a few years ago. 'We've had the place exorcised several times. The first was done by a Catholic Monsignor Alfred Gilbey, and the next by a spiritual friend of mine, but I don't think it did any good. David the resident butler thinks he heard something odd a few weeks ago in the Ghost Passage'.

One of the busiest of the Renishaw ghosts is believed to be Henry Sacheverell, a sickly child who drowned aged thirteen in 1726. The last of the Sacheverells, his portrait entitled The Boy in Pink, hangs in the magnificent dining room of Renishaw Hall. He has also become known as the kissing ghost because he has a rather surprising penchant for nestling up to lady guests and waking them with kisses from beyond the grave.

Tapped and Touched

John and Cynthia Ramsden have lived at Franshaw Hall since 1959 and had their first unexplainable encounter soon after they moved in, and they have been happening ever since. On one occasion, Sybil their cleaner at the time was using a vacuum cleaner in

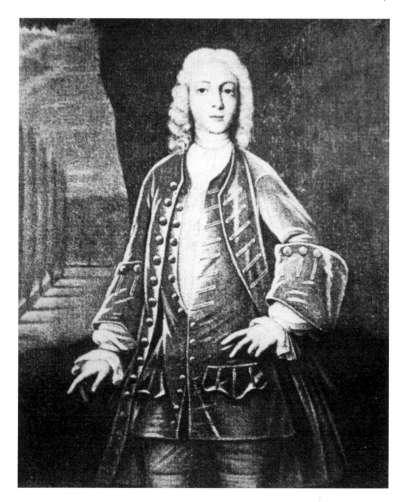

Henry Sacheveral
the Kissing Ghost

the upper corridor and felt someone tap her on the shoulder. Expecting it to be Mrs Ramsden, she turned to find no-one there. A friend of the Ramsdens staying at the Hall also experienced a presence in that corridor when he got up in the night.

More recently, Trish Bowden, their housekeeper was using a vacuum cleaner in one of the bedrooms when she felt someone touch her bottom. It was so unmistakable she thought she had backed into a piece of furniture, but when she turned she found nothing was there.

Pulled

The Old Revolution House, part of the Chesterfield Museum is a charming thatched cottage formerly known as the Cock and Pynot Inn (pynot is a Derbyshire name for magpie). It dates back to the seventeenth century when farmhouses also doubled as alehouses, but what makes this one special was that in June 1688, four noblemen met here to devise a scheme to dethrone James II and replace him with William of Orange. It became known as the Glorious Revolution as it was virtually bloodless, thus the change

of name. Furnished as it would have been in those far off days, it has retained its charm but it has also retained its ghosts. Many people have sensed a presence in the building although they stress it is not threatening. Some have seen a face peering through the small, leaded window. One lady looking out of the window, felt a tug on her cardigan as if it was being pulled by a demanding child. She turned, but she was alone. Others have seen a dog wandering through the room and some have felt it brush past their legs, but all agree that the atmosphere at the Revolution house is calm and welcoming.

Squeezed

There are various theories as to who or what now haunts The Victoria Arches, Chesterfield, and although there are no actual records, there are many tales told of deaths at the old foundries that were previously on the site. One member of staff was sent to do a stock-take in a store room, and felt arms encircling him from behind, squeezing his body until he could hardly breathe. Total fear eventually gave him the strength to break free but the experience had disturbed him so much, he never returned to work there again. It may be that the experience was a re-enactment of a dreadful accident that occurred when the premises were occupied by the Foundry. Ropes were attached to pulleys for lifting heavy good, but somehow a rope became wrapped around the waist of one young man who was dragged up to the roof as the ever tightening rope squeezed the last breath out of him.

Pinched, Punched & Pushed

Bolsover Castle is one of the most paranormally active places around. Ghostly knights have been seen walking round the thick wall that surrounds the Fountain garden. The apparition of a lady in grey walks through the wall where an archway that was blocked up in 1630 used to be, but the most appealing spectre of all is the little boy who joins visiting children in the Fountain garden and takes their hand.

All around the castle, people have reported being spoken to, pushed, slapped, tickled, pinched or their clothing tugged in a childish or familiar way. In the Little Castle, visitors smell perfume and pipe tobacco particularly in and around the Elysium room. The Castle has a book in which they encourage members of the public and staff to enter their ghostly experiences. It makes very interesting reading. One lady wrote in the book that she felt pressure on her back pushing her towards the fireplace in the Elysium Room and she even felt the heat from an invisible fire. I took a photograph of that fireplace and discovered a huge orb – the first manifestation of a ghost. (see the chapter Spirit Photography)

One member of staff while conducting a guided tour joked about Sir William being a bit of a ladies man when suddenly she felt a ghostly push. As she lurched forward, she sprained her ankle.

Strangled

Many years ago, the now defunct News Chronicle held a Christmas competition in which readers were invited to share their ghostly experiences. One prize winning contributor referred to an occasion when he had been cycling in the Peak District.

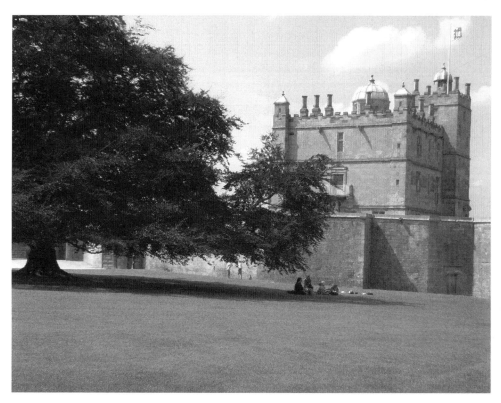

Bolsover Castle where vistors and staff have been pushed, pinched, slapped and tickled

Resting by the wayside at Wardlow Mires, he suddenly became aware of invisible hands gripping him by the throat and tightening almost to the point of strangulation. Recovering from this unnerving experience, he called in at the nearby Three Stags Heads and there heard the story of the murder of the toll bar keeper Hannah Oliver on New Year's Day 1815 by Anthony Lingard of Tideswell. Lingard was eventually arrested and gibbeted at Wardlow Mires, so were the ghostly hands those of Lingard once again enacting that dreadful deed which resulted in the last gibbeting in Derbyshire?

OLFACTORY HALLUCINATION OR WHIFFY GHOSTS

By this stage you might want to discount the idea that a ghost is caused by visual hallucination or tactile hallucination, but can we also dismiss what we smell as olfactory hallucination?

Astral Aromas
New people moving into premises often detect strange smells which can range from the stimulating scent of herbs and flowers to the less agreeable stench of blocked drains.

I've known people actually call in pest controllers to locate certain disagreeable smells believing them to be decomposing vermin, yet these abstract odours usually appear to be without a visible cause. That leaves us with the knowledge that we are probably dealing with the paranormal and the mysterious fact that we are able to detect astral aromas or smelly spirits that appear to be able to briefly assail our nostrils. The whiffs can be pleasant or pungent, and usually have some deep meaning and association with the deceased.

The Smell of Famel Syrup

Mrs H. Land of Bonsall told us about an incident concerning her late father who had been a carpenter by trade. He had carved some of the furniture including the pulpit, at the Imperial Road, Methodist Chapel (now part of the Imperial Rooms, Matlock).

Some years after her father's death, Mrs Land and other members of the family were attending a service at Imperial Road Methodist Chapel. They were sitting near to the pulpit when suddenly both Mrs Land and her sister became conscious of the strong aroma of a medicinal preparation called Famel Syrup. Other members of the family – whose sense of smell was by no means impaired – were sitting with them but smelt nothing. What made this so significant was that during his lifetime, when suffering from colds, their father had always resorted to taking Famel Syrup.

The Smell of Incense

In a 1951 article in the Derbyshire Countryside, Geraldine Mellor recounted a tale concerning Yhelt Cottage, a sixteenth century house near Buxton. During the period 1951-1953, the occupants were plagued by such poltergeist activity as crockery being rattled on the shelves, a hanging brass warming pan being swung like a pendulum, articles moving and electrics malfunctioning. Curious rosy lights appeared and disappeared on the bedroom walls and a strange, exquisite perfume like incense always appeared to accompany these activities. A priest was brought in to apply the ritual of exorcism and the activity ceased, but he was also able to supply the knowledge that Yhelt Cottage had once been the site of a nunnery. It is highly probable that the fragrant odour was created by the various aromatic substances burnt for their fragrant odour, in religious ceremonies performed at the nunnery.

The Smell of Bacon

The Grange on Southgate, Eckington is now a residential home for the elderly and although meals are taken at the normal times, in the middle of the night it is not unusual to smell bacon frying. The appetizing smell appears in various rooms and corridors, but it's not some form of midnight snack, because no one can trace its source.

The Smell of Eucalyptus & Disinfectant

Prior to the death of her mother, Mrs Nora Fullwood told how a combination of eucalyptus and disinfectant had been used for sanitary purposes and over a period of time, this particular pungent combination made Mrs Fullwood feel quite nauseous. After her mother's death, she was sitting quietly at home when she had a sudden strong

Imperial Rooms, Matlock

feeling that her mother was in the room with her. In fact she felt that her mother was so close, if she reached out she could actually touch her. Instinctively she said 'Hello mother!' and at that moment the room was filled with an overwhelming smell of eucalyptus and disinfectant.

The Smell of Lilies of the Valley
Another lady told how her father had been passionately fond of lilies of the valley which flower in late Spring, yet when he died in mid January, the room was filled with the scent of lilies of the valley.

The Smell of Her Father's Aftershave
Sandra Whitford was very close to her father and terribly upset when he died in 1997. At first she thought that it was her imagination, because often while driving her car she would get the faint whiff of her father's aftershave. This didn't bother her and she never mentioned it to anyone until one evening when her husband returned home, looking as white as a sheet. He described how as he was driving along when suddenly he felt the hairs on the back of his neck prickle. He felt really scared particularly when he got a whiff of aftershave and heard a distinct cough.

The Smell of Pipe Smoke

Goss Hall or Gorse Hall as it was formerly known, dates back to the sixteenth century and stands above the village of Ashover on the coach road to Overton Hall. It was originally owned by the Deincourt family and eventually passed to a member of the Babington family. Anthony Babington is said to have taken refuge in the cellar of Goss Hall following the discovery of his plot to rescue Mary Stuart, Queen of Scots from Wingfield Manor.

The Hall is also said to have belonged to Sir Walter Raleigh for a short time prior to this, so is it surprising that it should have a ghost that smokes a pipe which fills the house with tobacco smoke? (Sir Walter introduced tobacco to this country.)

The smell was apparently so bad in the 1950s that is caused one owner to leave, and although it became almost a ruin, Goss Hall is now a very desirable private house.

No Smoking Please

Gordon and Hannah Robinson are non smokers and when friends and neighbours visit they respect their wishes not to smoke in their home at New Road, Eyam, but how can you stop a ghost from leaving the smell of tobacco all around the house?

'We never actually see the smoke or the ghost,' said Gordon, 'but the smell is unmistakable. We don't mind having a ghost. We first noticed him several years ago when objects started to move mysteriously and a glass chandelier hanging in the living room was several times found lying on the floor totally undamaged. He isn't any trouble and we would hardly notice him if it wasn't for the pipe smoking.'

Strange Smells at Stoney Middleton Hall

There is no record of any ghosts at Stoney Middleton Hall but there are a number of instances of phantom fragrances. People sleeping in a certain bedroom are affected by the strange, inexplicable smell of sulphur, yet there is no fire in or anywhere near the room. It was so strong and insufferable on one occasion when the daughter of the house and a friend slept in this room that not only did it wake them, they had to get up and open the window.

A much more pleasant aroma drifted into the dreams of some friends who were staying with the Jessops at the time when they owned the house. They were woken by the appetizing aroma of bacon frying, yet in the small hours of the night it wasn't a midnight snack or an early breakfast. Not only was no meal of any sort being cooked, the bedroom was so far from the kitchen, they were unlikely to have smelt anything if it was.

Eyam Old Laundry

One of my strangest experiences concerning smelly spirits happened at the old laundry of Eyam Hall. It's a single roomed detached stone building built over a well in the yard. Disregarding the grid, the well is still open in the centre of the room. There's a story that in 1777, a servant girl named Sarah Mills fell into the well and was drowned. Some years later, when repairing the sides of the well, workmen discovered human bones and not knowing what to do with them, put them back. Ever since, people have reported strange sensations in the old laundry. It can be either very cold or very warm for no apparent reason, and people have felt like passing out.

On my visit, the group I was with began commenting on the way their breath clouded, and to prove the point, people started huffing out balloons of cold breath. The temperature inside was certainly dropping rapidly and one of the group started dithering and pacing round as if in major discomfort.

It was then that I started to feel a tightening in my chest and throat as if I was coming down with a cold. I had difficulty breathing due to a hot, damp atmosphere like you'd experience in a sauna, but this was cloggy and stale, the soiled, dusty smell of dirty, wet clothes, soapy washing water and clothes being boiled. Suddenly, I was transported back to my grandmother's scullery on wash-day. It wasn't an hallucination. It wasn't my imagination, and it wasn't the props like the boiler, dolly tub, rubbing board, poncher or pull up airing rack hanging from the high raftered ceiling.

I screwed up my nose in distaste and tried to cover my mouth but I had to get out of the place. The smell lingered with me until I was outside in the fresh air. The obvious solution would be that earlier that day, some of the hall staff had put on a practical demonstration of how washdays would have been conducted in Victorian times, yet surely a demonstration would not have been so exhaustive and thorough.

Thinking about it logically the smell would also have been obvious when we first entered the room which prior to our arrival was locked. A closed room would have retained the smell but it hadn't. I asked if anyone else had felt overcome by the smell. No one else had. And finally, I checked if there had been a demonstration that day and was told no. Further more, I was assured that the laundry has never staged such a demonstration.

Like all other mysterious psychic phenomena, if we discount smell as olfactory hallucination, we are left with a complete mystery to which we can apply no logical explanation. All that we know is that the departed are somehow able to activate our sense of smell as a means of communicating with us.

AUDITORY HALLUCINATION OR NOISY SPIRITS

It's understandable that we should look for rational explanations for these incidents, but having looked at the idea that a ghost 'might' be caused by visual hallucination, tactile hallucination and olfactory hallucination, lastly lets consider auditory hallucination. Are there sounds which have no apparent external cause generated by the brain of the person even though they believe them to be external in origin?

In Peakland folklore, the frightening howling and yelping sounds of the hounds of death are said to emanate from the night sky as they hunt down their next victim. In North Derbyshire they are known as Gabriel's Hounds or Gabble Ratchets from 'rache', a term for a hunting dog.

In 1870 the Sheffield newspaper reported how the Gabriel's Hounds had been heard above a house in Bradfield shortly before it caught fire, killing a young child.

A Peak Forest woman avowed that she heard them howling on the night her brother died in January 1987. They listened as the sounds increased to a crescendo at 2.a.m., the exact time her brother passed away.

Could the cries of the Gabriel hounds be made by a flock of flying geese, or could ghostly voices engaged in excited conversation be the babble of a brook?

Outside, sounds like galloping horses carry on the still air, but how do we explain the sound and vibration of marching feet? This is an action repay that dates back to the year 80 AD when Julius Agricola the Roman General, having defeated the Cornavii tribe advanced up the north-east horn of Cheshire to attack the Peak dwellers who were part of the kingdom of the Brigantes. Having defeated the local tribes, the Romans, attracted by the lead that was mined in the area remained for another 300 years and the sound of their marching feet is often heard along the long stretches of inhospitable moorlands between the Roman camps of Navio in the Hope Valley and Melandra on the outskirts of Glossop.

The most reported incidents in haunted houses are the sounds – footsteps, doors opening or closing, floor boards creaking, and splashing water, so we could ask, how are these created when ghosts have no physical weight to cause an impact?

Phantoms can produce the sounds of singing, sobbing, sighing or screeching, yet how can we explain this when they have no lungs, or vocal chords, or any of the other physical organs essential to respiration and articulation?

'I CAN SMELL YOU!' YVETTE FIELDING TOLD THE NOISY GHOST

Matlock Bath Pavilion is Pulsating with Spirit Life
When Living TV's *Most Haunted* team visited the Matlock Bath Pavilion in the Spring of 2007, they verified that it's pulsating with spirit activity and they never once considered hallucination. On the first floor there is a strong male presence and cold spots on the upstairs corridor. Machinery noises have been reported. Footsteps are heard that sound like shoes on concrete yet the floors are carpeted. On the upper floor of the Dome, something was thrown at the team, the place went very cold, and the trap-door stuck. They couldn't open it but could feel some form of vibration as they tried, and they had to telephone for help to get out.

On the ground floor which since 1978 has housed the Lead Mining Museum, footsteps and bangs are heard regularly and the team experienced a feeling of unease that couldn't be explained. David Wells the psychic investigator was able to communicate with a spirit named Tom who died aged thirty-six to thirty-seven, probably crushed to death in the mine. Tom is not alone. There is another man called Robert. He's a sinister presence and responsible for the banging and whistling that is regularly heard. The presence of both these men is obvious from the smell of body odour and the sound of heavy wheezing which was picked up very clearly by the sound equipment.

A light bulb exploded near them, they saw rubbish stacked in a corner move, and heard footsteps, sighs and bangs.

Yvette Fielding the presenter asked, 'Was that you Robert?' She received two taps in response. 'I thought so, I can smell you,' she replied.

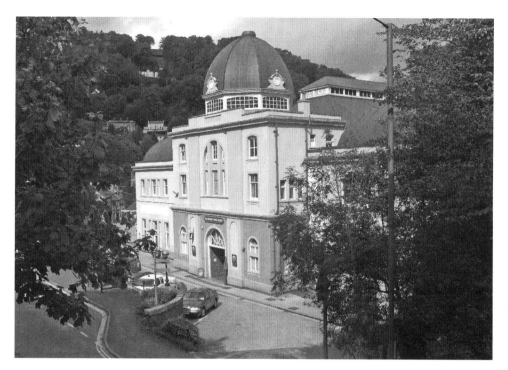

Matlock Bath Pavilion is pulsating with spirit life

Slamming Doors that Did Not Activate the Alarm

Fred and Annie were rudely awakened in the middle of the night by the sound of slamming doors, coming from the floor below where three rooms with interconnecting doors had been knocked through to form one large living space in a 1972 conversion. The doors they had heard slamming had in fact not been there for over thirty years, and needless to say when they went to investigate, they found nothing out of place. They found the whole experience quite amazing. The sound of banging doors had been so loud it had woken them both from sleep, yet it did not set off the alarm which was otherwise working perfectly.

The Footsteps at Platchett's House

Harold and Norah Kirby lived at Platchetts House, Breedon Hill from 1952 until it was demolished in 1966. One evening Harold and Norah Kirkby and their other children had gone to bed leaving their nineteen-year-old daughter Pat studying downstairs. As usual they had left the landing light on, with instructions to Pat to turn it off when she went to bed. Some time later, they heard footsteps come up the stairs and waited for the landing light to be switched off but after waiting quite a time, thinking Pat had forgotten, Norah got up to do so. She peeped into Pat's room but found it empty. Rather surprised, she went downstairs and found Pat had fallen asleep in a chair.

Norah's mother was told of the incident and she admitted that on a number of occasions while staying at Platchetts House, she too had heard the footsteps, although

instead of walking up the stairs they were always going down. They would then walk along the stone path under the window. She had heard them so many times, she had fallen into the habit of counting them and always there were eleven steps down the stairs, then thirteen steps outside. Norah's aunt had also experienced this while staying at Platchett's House and she too confirmed that she had heard the same number – eleven down the stairs and thirteen outside.

The family could find no explanation for this, but the mystery deepened when the house was demolished by the quarry company, and human bones were found buried in the garden.

THE CREAKING FLOOR BOARDS AT CASTLE HOUSE

Jim Marlow was a butler at Castle Hill House, but Jim was finding life unbearable and one day he flipped. He left the butler's pantry closing the door behind him, walked along the corridor and up a flight of stairs to the gun-room where he selected a suitable gun then returned to the pantry where he locked the door behind him. A few minutes later, there was a loud bang and Jim Marlowe had shot himself.

This sad incident happened on a Friday evening and apparently, every Friday evening since, if you listen carefully you will hear Jim Marlowe re-enact his last walk from the pantry to the gun-room. There is a loose floor board at the entrance to this room and it is heard to creak ominously under the weight of the phantom's footstep.

Castle House where creaking floorboards are heard on Friday evenings

Heavy Breathing

In the late 1980s Susan Herbert was a regular volunteer at The Grange, a nursing home in Eckington. Along with a team of other volunteers, she often supervised jumble sales and other charity events to raise funds. On one occasion, with the help of a colleague, Susan was carrying boxes of jumble up a flight of stairs into storage. The two women chatted as they moved the boxes and after several trips, Susan realised that her companion who was following her up the stairs was strangely quiet. She could still hear her breathing heavily from the exertion, and felt her close behind her, but when she reached the top of the stairs and turned round, Susan was alone. Her colleague was still downstairs, so who had followed her?

Music in the Night

After the death of her husband, a lady moved into the Matlock cottage of her son and his wife, but almost a year before her death, she used to say in the morning; 'Did anyone hear music and singing in the night?' The answer would always be 'No'. despite the fact that the bedrooms were adjoining. At first she described the music as distant but after a few weeks she could distinguish the words sung and sometimes knew the tune. At times it was secular music but usually that of a hymn. She would describe it as a full choir of singers and very beautiful – supernatural songsters that kept her company during wakeful hours and continued with her to the end.

Footsteps and Phantom Singing

Mr & Mrs Dennis Slater lived in a cottage at East Bank, Winster where occasionally they were woken in the night by a series of bumps on the stairs. Going to investigate there was never any reason for the mysterious bumps which were always the same number and regularity. One night when Dennis went to investigate, he tripped and fell down the stairs – the same number of bumps at exactly the same intervals. After that, the Slaters never heard the bumps again.

This cottage had previously been purchased by a sailor who went off to sea and never came back, at least not in the flesh. Often Dennis heard footsteps crossing the bedroom floor, sometimes even when he lay in the bed. Although he never saw anything, his nephew did and described the apparition of a sailor. Another relative scorned the idea until one night she was left in charge of the house while the Slaters were out. When they returned, they found the door open, the lights and TV still switched on and no sign of the relative who later admitted she had heard the ghostly footsteps and freaked.

But it wasn't just footsteps that were heard. On one occasion, a friend had called to watch TV with Dennis, and during the programme he enquired whether Mrs Slater, was upstairs rehearsing as he could hear singing coming from the room above. Dennis assured him his wife was not even in the house but as he listened he too heard someone singing in a clear soprano voice. As he quickly ascended the stairs to investigate, the singing stopped and there was no sign of the singer. What made this incident even more strange was the fact that Mr Slater's friend was quite deaf.

Hanging Around
Mr Francis Fisher, a former secretary of the Derbyshire Archaeological Society was a keen collector of ghost tales. His fascination with the subject probably stemmed from a story told to him by his aunt when he was six years old. Sitting with his aunt by the fireside of her home, bumps could occasionally be heard on the floor above. The house was old and bumps seemed natural, but these particular bumps had a more sinister origin according to his aunt. Apparently a former resident had hanged himself in the room above and when the tragedy was discovered the dead man's heels were just touching the floor. When the door was opened, the wind swayed the suspended corpse, causing the heels to tap the floor. That same house had a heavy front door which occasionally seemed to shake violently as if someone outside was trying to wrest it from its hinges.

The Old House Museum Ghost
No visit to Bakewell is complete without a visit to the Old House Museum. manned by a dedicated group of volunteers. One of the ladies told me that she was upstairs sorting through some things when she heard the front door open and footsteps walking along the stone floor. This surprised her as she knew the door was locked and she was alone in the building. Because of the gaps between the floor boards, it is possible to see through from the first floor down to the ground floor, and she peered through the cracks to see who could possibly have entered. She called, but there was no reply. The room was empty but unconvinced she went downstairs to check. Despite a thorough search, she was alone.

Spectral Horses
Up to a century ago, the horse market was held outside the Castle Hotel, Bakewell and the horses exercised along Castle Street. About thirty years ago, George, a former resident of Castle Street was woken regularly by the sound of horses walking up and down the street. This became such a regular occurrence that on one occasion waking in a grumpy mood he decided to give the early morning equestrian a piece of his mind. He leapt out of bed, drew back the curtains and opened the window, but instead of seeing a horse and rider the entire street was deserted and the sound had simply gone. George had somehow tuned into the sound of ghostly horses being trotted along this road. He had heard a complete repeat of an actual incident that occurred regularly many years ago, an event imprinted like a time recording in the ether.

Charlie's Retreat has Left a Ghostly Legacy ...
On 3 December 1745, HRH Prince Charles Edward Stuart, better known as Bonnie Prince Charlie, accompanied by a bodyguard of Scottish lords, the music of bagpipes and an army of seven thousand, crossed the county border from Staffordshire to Derbyshire. The Prince was leading the Jacobite Rebellion on their march to London in an attempt to re-establish the Stuart succession. They reached Derby the furthest point south and an advance group of seventy Scottish soldiers were sent to Swarkstone, seven miles south of Derby to secure Swarkstone bridge. This was the only way of

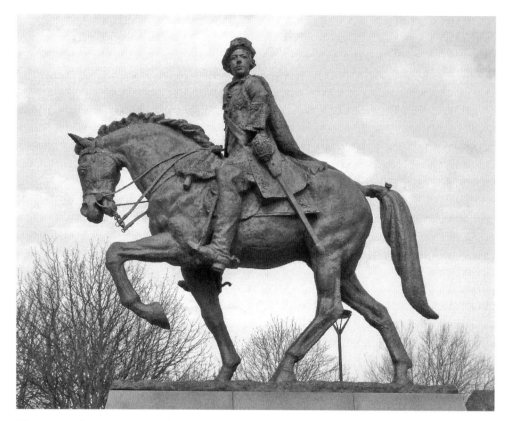

The statue of Bonnie Prince Charlie in Derby

crossing the River Trent on their march south, yet on 6 December they were recalled and began their long march back to Scotland. But have they left a lasting legacy? Many people report hearing the sound of horse's hooves and the accompanying clatter of armour and swords around Swarkstone Bridge, although the ghostly cavalry never materialise.

... or Two

A similar incident happens at Drive Lodge leading to the southern entrance of Elvaston Castle. Peter Fowler was lying in bed in the early hours of the morning unable to sleep when he heard horses hooves passing by. Initially he thought it must be a horse and cart but as he listened, he realised it was not just one horse but a whole troop. Anxious to have a look at such an unusual sight, he leapt out of bed, went over to the window and threw back the curtains. He peered both left then right up and down the street in both directions but could see nothing. What made this even more amazing was that he could still hear them quite distinctly, accompanied by the sound of men calling to each other. He mentioned this to old George who had lived in the village all his life and was told that he wasn't the first to hear the phantom horse, believed to be a troop of soldiers from the time when Bonnie Prince Charlie got as far as Derby before retreating.

... or Three

At Bolsover Castle visitors and staff have heard the sound of horse's trotting up the south drive and at one re-enactment, foot-soldiers were joined by others from a former era. Lights move around as if from candles carried by ghostly hands and many visitors experience a feeling of being watched.

Spectral Horses Also Heard at Edale

At Edale the sound of galloping horses are regularly heard, and the most told story concerns three parish councillors who were returning from a meeting one evening. They heard the sound so distinctly, they thought they were runaways and the men took a stand across the road in order to stop them. There they stood waiting, and despite peering into the gloom, they were unable to see the oncoming horses and stood helpless and amazed as the sound of beating hooves galloped past then died away in the distance.

Scream and Splash

More distressing is the prolonged, blood curdling scream followed by splash like a heavy weight or a body being pitched into the pool where the pack-horse bridge spans the tiny River Noe at Edale. These are the sounds that have been heard by many villagers and visitors, and are said to be the echo of an incident when a boy was dragged from the now ruined Edale Head Farm and drowned in the stream.

Chattering Travellers on the Old ALR

I was interested in the Ashover Light Railway which closed in the 1950s but is likely to be re-instated along its old route in the near future, and I went to look at one of the remaining station buildings at Fallgate, Ashover. It's almost derelict, situated in a tranquil spot by the river and I was quite alone. As I approached the building, I paused because the door was closed and from inside came the sound of voices. Obviously several people were in the small wooden building and I waited patiently for them to come out. They didn't, and after a while I pushed open the door ready to apologies for the intrusion but the room was empty and the voices stopped immediately.

Ethereal Music

People regularly report hearing ethereal music coming from closed churches. A story told to me by a member of the National Trust staff at Ilam Hall involves a resident of Ilam who does not wish to be identified, so we will call him Joe. One evening Joe left his comfortable fireside to lock the church. It was only a short distance from his home, but it was cold and dark, and not the kind of night for loitering. Before locking the church, he did a cursory check of the inside, sweeping his torch round the empty church, yet it was not empty. Sitting at the organ was a ghostly figure and ethereal music filled the church. Without stopping to investigate further, Joe turned and ran.

At Alderwasley Chapel off Higg Lane a branch off the A6 at Whatstandwell, people have reported hearing the sounds of shuffling feet, organ playing, bells and singing.

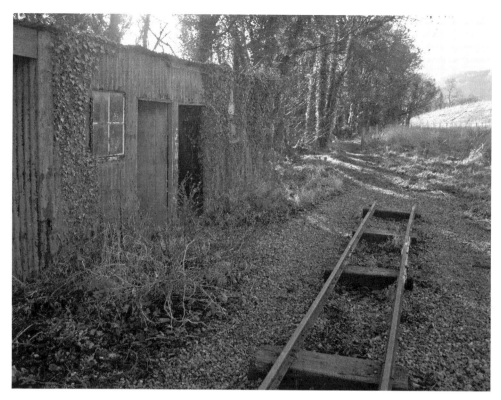

ALR Fallgate Station where ghostly voices were heard

If you walk past St Chads Church on Wilne Road, Draycot and hear organ music being played don't automatically think this indicates a service is being conducted or the organist is practicing. It doesn't. Many people have heard hauntingly sad music coming from inside the locked church, and a young man named Martin Astle is said to be responsible. Martin had just been rejected by his sweetheart, and broken hearted he went to the church where he sat playing the organ. After a time, he left, walked down Wilne Lane to the old mill and hanged himself from a beam. Apparently Martin is still re-enacting the incident. A courting couple were parked in the lane one evening when walking towards them from the church came a young man dressed in Victorian clothes. His attire was strange enough but they watched in horror as he passed through the wing of the car and continued down the lane towards the mill.

The Sound of a Harpsichord Heard at Carnfield Hall
Carnfield Hall is a fifteenth century hall situated on the B6019 road between Alfreton and South Normanton, built originally as the Manor House of South Normanton. In 1987 under threat of demolition and having stood empty for thirty years, it was bought by James Cartland who embarked upon a massive restoration and renovation program. It could be that James also stirred the ghosts as Carnfield Hall has been described as the perfect haunted house with atmosphere.

A shadowy figure has been seen at the bottom of the main staircase, strange noises like furniture being moved and footsteps are heard at dead of night, there are definite cold spots and numerous visitors have sensed something unnatural about the Hall. According to legend, every year Carnfield has a Ghostly Ball, a re-enactment of a party given to celebrate a previous owners appointment as High Sheriff of Derbyshire in 1700. That must have been some party!

A team of ghost hunters investigating the Hall made a recording in the Great Parlour and captured the sound of a harpsichord being played. Experts identified it as a rare organ harpsichord, and James Cartland later found in an inventory that such an instrument had been given as a wedding gift by Sir Nicholas Wilmot to his daughter in 1666. The Hall has obviously known much music and laughter. A TV crew filming outside the Hall captured shadowy hands, one with a great white lace cuff, raised as if in some dance movement. The Great Parlour dates from the sixteenth century so ladies and gentlemen in seventeenth century clothing would be quite at home there.

A Sixth Sense

Having looked at the way four of our five senses (discounting taste) perceive spirit, it seems a good time to mention the popular term sixth sense. This idea is based on the fact that the human mind has the faculty to gain and transmit information which lies beyond the usual five senses – thus a sixth sense. It is also described as ESP which actually stands for extra sensory perception, a term which is used to explain the receiving and sending of information by psychic means.

Until recently people who experienced something that could not be explained by their five senses grasped at anything that might give the answer, so they attributed such experiences to coincidence, divine intervention, earth energy, spirit guides, astrology or celestial events like the influence of the sun, moon, planets and stars on human behaviour.

Despite the fact that it contradicts the fundamental laws of physics and continues to baffle scientists, psychic ability (abbreviated to PSI) has long been recognised as a gift possessed by psychics. It can take the form of telepathy, also known as person to person ESP, clairvoyance the ability to gain information about objects or events, and precognition the ability to prophecy future events. Until recently anyone with a belief in a sixth sense were regarded as illogical, eccentric or mad, but American businessmen are now using psychics to advise them in multi-million-dollar business deals, and governments are researching ESP as a potential military weapon. Even more surprising, it is now recognised as a part of human functioning and not just something unique to a few gifted individuals

We all rely upon our senses to interpret everyday happening whether they are sounds, smells or sights, but sometimes they are templates out of which all manner of things can be moulded by the human mind, bending reality to fit human expectation, legend and suggestibility.

Image the stereo-type ghost scene whether it's a deserted street or lonely hillside. Observing conditions are bad, dark or foggy with swirling mists that shade the distance,

shrouding trees and buildings until they assume fantastic shapes. This all adds to its eerie nature. There's a chilling silence, then suddenly there's a strange noise or an indefinable shape looms out of the cloudy mist. In this kind of situation it is not unusual for people to report the shape as threatening because the observer has by this stage been reduced to blind panic. The imagination is running riot! Could it be a demonic beast or an alien spaceship? Isn't this area reputed to be haunted? Wasn't there a great battle, a gallows or brutal murder on this site? Subconscious suggestion, expectancy and belief affect perception and we allow the imagination free reign to interpret the images that the conscious eye sees. But what if we can't blame an overactive imagination or some sort of mental mirage? What was it that you saw out of the corner of your eye? Did you see it or did you imagine it?

Action Replays

We all know the feeling of entering a room and being aware of a highly charged atmosphere. We instinctively know that something is going on, something that we are not involved in, probably some highly emotional event that is proving to be extremely traumatic for those involved. It is thought that action replays are similar to this. It's like looking at a hologram, viewing the same scene but in a different time. There may be noise and people may be speaking but it will be to others in their own time. It is extremely rare if they respond to anything the viewer does. It's a case of people returning and doing what they did in life, but how can inanimate objects somehow leave an impression of a long-ago event imprinted like a time recording? How can energy signals from emotive events become recorded in the ether? How can a whole scene turn into an action replay?

Powerfully emotive events, high emotions, suffering, fear, stress, anger, pain – a catalogue of highly charged events tied to the trauma just before death, particularly if it is sudden or violent seem able to imprint themselves indelibly in the ether. That could send out some kind of psychic distress flare that permanently alters the feeling or vibes of a place. In these situations, brain waves which can be recorded on an electro-encephalograph, become more active, and when they reach a particular pitch, it's possible that they can be picked up and stored by certain substances.

That could explain why people have reported seeing Roman soldiers, Cavaliers (though surprisingly few Roundheads) and Jacobite soldiers. More recently we have phantom soldiers and airmen from the last World War (see also Aerial Phantoms).

Aviation historian Ron Collier has spent the last thirty years studying the Peak District aircrashes that occurred during and after the war, and which have left us with some strange paranormal activity.

The Ghost who Watched
While on a flight from RAF Scampton to Warrington in Cheshire in 1948 a US Air Force B29 Superfortress lost its way in low cloud and exploded at Higher Shelf Stones 1,600 feet up on the summit of Bleaklow. All thirteen crew including Captain Langon

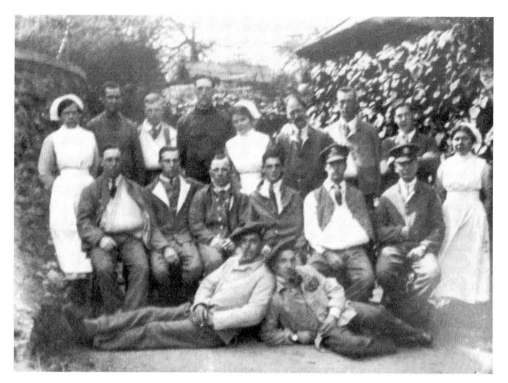

Traumatised soldiers can leave a ghostly legacy

P. Tanner died in the crash. Today pieces of the wreckage can still be seen half buried high up on the exposed summit, and there's a simple shrine and a plague to commemorate the event.

As a Glossop schoolboy, historian Gerald Scarratt witnessed the aftermath of the crash and returned to the wreck with his son a quarter of a century later. While scratching around in the earth, he found what he thought at first was a metal washer, but after cleaning it up, he discovered it was a gold ring engraved with the name of the plane's captain Langdon P. Tanner. Shortly after the discovery was publicised, a group of aircraft enthusiasts asked Scarratt to show them the place where he found the ring and he agreed to take them to the crash site at Bleaklow. 'I bent down to show them where I had found the ring and when I looked up they had all scarpered and were ten or fifteen yards away,' he said. 'When I caught up with them, they were ashen faced. They said they had seen someone standing behind me, looking down and dressed in full flying uniform.'

The Dying Moments of an Airman
Vic Hallam is the instigator and founder of the Derwent Museum housed in one of the twin towers on the Derwent Dam. It is dedicated, not just to the local people and the building of the string of dams in the valley, but also to The Dambusters who used this dam to practice the bouncing bomb. Vic also has a wealth of paranormal stories

The Spirit of an Army Officer haunts the carriage at Butterley

collected from people who he considers to be reliable and believable. One such story was told to him by a walker who had been standing on the walkway looking up the valley of the Derwent Dam. It was a damp, misty morning but his attention was drawn to a light reflected in the water, and before his terrified eyes, the figure of a ghostly airman emerged from the water. He was dressed in an old brown greatcoat with a sheepskin collar, and his back seemed to be on fire which explained the light seen reflected in the water. The walker saw him clearly and watched as he walked out of the dam and disappeared into Hollingsend Wood. The walker was emphatic that it was definitely the figure of an airman or bomber pilot of World War vintage, and when he told Vic Hallam the man was sincere and convincing

The Ghost in the Carriage at Butterley

The Midland Railway Trust, Butterley operate one of the finest working museums in the country, devoted entirely to railways. They have working locomotives from the golden age of steam, to engines and rolling stock of more modern times, and a ghost. Jane and Bill visited the museum on bank holiday Monday May 6th 1991. They left the main complex on a rough track past rows of old trucks that gave a strong impression of decay and dank neglect and as they approached one particular coach Jane felt an intense atmosphere. It made her feel both frightened and sad. Something made her glance through the open door of the coach and sitting there was the ghost of a man. According to Jane, 'He was a sort of translucent, misty apparition with no definite details. I could see right through him, but could tell he had dark hair and was wearing

a green coat, and fawn trousers. I knew he was dead; don't ask me how. There were no injuries or blood or anything, but I just knew he was dead.'

Jane saw the ghost in good light, at roughly eye level, and from a distance of only a few feet. It was about 3.00pm. The weather was cold and dry but dull, not the sort of conditions for reflections or shadows.

Other people have also expressed anxiety, agitation and a feeling of foreboding near this coach. Railway trust members dislike being on their own in this area. Mr Alan Calledine, Development Officer of the Railway Trust said – 'The vehicle concerned was built in 1914 by the Midland Railway and is the type of coach used quite extensively for troop movement during the first world war. The green jacket and fawn trousers would tie in with the uniforms worn by Army Officers. Also at that time these coaches were used for bringing injured soldiers back to local hospitals for treatment and to bring the bodies of the fallen home for burial.'

So could this be the ghost of a dead or injured, extremely traumatised soldier returning home?

Action Replays That Are Not Linked to Trauma

At one time it was thought that the event needed to be highly charged in order to register, but that is not always so. Action replay events are not necessarily dramatic battles or murders, they can be amazingly trivial, a look back at what someone once did. The event can be anything that has somehow become imprinted in the ether. It may be that certain atmospheric or geological conditions are needed to record and hold it. It might be that certain rock formations containing particular minerals, or certain levels of humidity or temperature all need to combine to produce a recording.

What exactly triggers the replay is also uncertain. Perhaps it is the recreation of the same atmospheric conditions or perhaps a totally different set of conditions need to exist. Perhaps percipients with one set of 'brain frequencies' can perceive what others can't, to replay when similar conditions occur, or when a suitably sensitive individual presses the play button.

What Visitors?

Going to visit her friend Olave Rutherford in Derby, Joan went in through the back door and as Olave wasn't in the kitchen, popped her head round the sitting room door and stared in surprised disbelief At a small table sat two ladies in what appeared to be fancy dress. Joan stammered an apology for disturbing them and left the room almost colliding with Olave in the passageway.

'I didn't know you had visitors?' said Joan.

Olave looked surprised. 'We haven't.'

Joan pushed open the sitting room door and they both looked into the room, but it was back to normal, and the ladies had gone.

Feeling very shaken, Joan had a strong cup of tea and described the two ladies. Olave felt this was something she should research and has since found on the 1901 census that two sisters had lived in the property. So did Joan somehow walk into a time warp and see the previous occupants of the house who had died over seventy years previously?

Two ladies sat in Olave's sitting room, in what appeared to be fancy dress

It can't be ignored that stone houses made of the local millstone which is rich in quartz have more paranormal 'visitations' than brick houses. Quartz crystals – like we find in a watch – are thin plates or rods, cut in certain directions from a piece of piezoelectric quartz and accurately ground so that they vibrate at a particular frequency or when under pressure, to generate a small charge of electrical energy. Could this cause a reaction that not only records an event but allow us to tune into some form of time travel?

No one has yet found a fool-proof answer to how or why we are able to tap into this paranormal power, we just have to accept that something in the ether appears able to record these things like a loop of film or a sound tape which can be rewound and played again for new audiences. It can happen at random times and in chance places so perhaps one day you might be the one able to press that re-play button!

Swanick Hayes
In 1860, Francis Wright a partner in the nearby Butterley Company, built The Hayes at Swanick, but in 1910 it was purchased by the Student Christian Movement of Great Britain and Ireland to be used as a student conference centre. Visitor numbers increased during the 1920s and '30s but in 1939 with the outbreak of the second World War, the Hayes was quickly taken over by the War Office to become a Prisoner of War camp.

Barbed wire fences and watchtowers were erected around the perimeter of what was to become Camp 13 for German Air Force officers, and amongst them was Franz von Werra, who was keen to escape. After a thorough reconnaissance of the camp, he reverted to the classic means of escape for the POW – the tunnel, and tunnelling began in a disused room on the corner of the ground floor of the Garden House – later to become room 102.

Does Frank von Werra haunt Swanick Hayes?

After a month the tunnel was ready. Five prisoners escaped but their freedom was short lived. Two were arrested on their way to Nottingham, two in Manchester, but Franz von Werra, posing as a Dutch airforce officer undertaking secret tests made his way to Codnor Park Railway station. There a suspicious ticket collector called the police who interviewed Franz von Werra. He obviously fooled them completely because they organised a car to take him to the nearest RAF base at Hucknall.

Whilst Squadron Leader Boniface, the suspicious duty officer at the base was checking his story, von Werra climbed out of a toilet window and made his way to the next door Rolls Royce factory where a final fitting was being done on a prototype Hurricane. He convinced the fitter that he was taking the plane for a test and was issued with a parachute, but while the fitter went to find a trollyack – the portable battery pack to start the engine – von Werra was arrested in the cockpit.

In 1956 Kendal Burt and James Leasor wrote the book *The One That Got Away,* chronicling the true exploits of Oberleutnant Franz von Warra and the following year it was made into a film of the same name. But that's not the end of our story.

After the prisoners had left The Hayes, conferences returned and in 1949, the Writers Summer School was added to the clientele.

My first experience of attending The Hayes Writers' Summer School was in 2001. The Garden House was still being used as guest accommodation and I found the atmosphere rather austere. The tunnel which allowed the prisoners to escape under the barbed wire perimeter fencing was still there, so its not surprising to find that so are its ghosts.

The Garden House Swanick Hayes

A conference visitor was woken at 5.30 by the sound of heavy marching feet outside the Garden House, yet there was no one there. Another person heard the clatter of heavy boots on the wooden stairs early one morning, yet the stairs were carpeted. One woman attending a writers conference apparently saw a man in German officer's uniform standing by her dressing table. Her room was 102.

Note: Because of The Hayes policy of ongoing alterations, upgrading and refurbishments, the Garden House has now been demolished.

The Gardens

The mock Tudor building called The Gardens in Shipley Park was built in 1882 as the Dower House to Shipley Hall, but it was never actually used by any Miller-Munday widow probably because the lady for whom it was built caused a great scandal when she left her husband and had an affair with the Earl of Shrewsbury. The Dower House had a change of name to *The Gardens*, possibly because the first occupant of the house was Shipley Hall's head gardener. He suffered a mental breakdown and his successor was John Crago Tallack who in 1909 fell down the stairs. His injuries caused him to suffer months of physical and mental anguish and finally he committed suicide by taking cyanide.

In September 1978 Barbara and Geoffrey Cuthbert moved into *The Gardens* and soon after moving in, strange events began to take place. They heard footsteps in the

bedroom and at times, their bed was violently shaken. Barbara was woken one night by the sound of running water and found that all the taps in the bathroom had been turned on. When it became obviously that they could not turn them off, the water had to be shut off at the mains. Whenever the porch light was turned off at night, it was always found to have been switched back on again. There was no sensor attached or reason why this should happen but when a workman called to repair it, he saw a figure glide through the closed door. Could all this paranormal activity be linked the poignant plight of the house's previous occupants?

Heage Hall

Robbery, murder, ghostly appearances, drink, deceit and downfall – Heage Hall has it all. It is reputed to predate 1600 having been owned by the Dethicks, the Poles then the Argyles in the seventeenth century. According to legend, it is one of the local places visited by Mary Queen of Scots. A pane of window glass found last century is supposed to have been inscribed by her – 'Trop heureux en toi, Malhereux en moi'. The writing has been authenticated as dating from the sixteenth century. There is also supposedly a tunnel linking it with Wingfield Manor – which large house does not claim to have such?

Mrs Poole returned to terrorise her husband

Looking at it today, it's hard to imagine that this was the former mansion of a gentleman of noble descent, named Charles Poole Esq. who married a lady of suitable rank and had two daughters. But George Poole was a cruel and tyrannical husband and father who had a dreadful temper. He heaped abuse on his servants, whipped his dogs, cursed his horse, abused his wife and drank to excess. Mistreated by her husband who according to accounts destroyed every virtue and human feeling, Mrs Pool led a strange, unhappy life, and there are rumours that she starved herself to death after being driven to despair.

Shortly after her death, it began to be whispered amongst the servants that Mrs Poole had returned to haunt the hall. There were reports of unusual temperature variations, unexplained noises, strange smells, lights of unknown origin and poltergeist activity. Was this Mrs Poole in an apparent fit of phantom pique? Charles Pool tried to stop these rumours, yet his behaviour did just the opposite. He would not go out after dark, and kept a light constantly burning in his bedchamber during his sleeping hours. Pool felt it necessary to call in spiritual help and the then resident clergy of Duffield visited him regularly. To ease his conscience, he was persuaded to show repentance by building a chapel of ease at Heage. He did so very begrudgingly and it still bears his initials and date (CP 1646).

When the Civil War broke out, Pool did nothing to help either cause, being determined to keep what was his for his own use. He buried his gold and title deeds in a ravine a quarter of a mile from the hall for safe-keeping, then after the war, it was transferred back to the hall where it was kept in a huge iron-bound coffer secured by several locks, the keys of which he either kept on his person by day or under his pillow at night. Towards the end of his life, Pool employed a man called Edward Ridge and it was he who was with Pool when the old man died. Messages were sent to his two married daughters to proceed to Heage Hall in all haste, and the mortal remains of Squire Pool were buried with little pomp and ceremony. Immediately the funeral was over, the chest was opened and all present stared in amazement because the chest was empty.

There were strong suspicions that Edward Ridge had taken the gold, but they could prove nothing and no charges were ever brought against him, yet hardly had the talk of the robbery died down before the inhabitants of Heage and the surrounding villages reported that Poole had come back in spirit to haunt the place. He had been seen riding in his coach pulled by four swift horses driving across the common at Belper towards the Hall. Those who had seen this apparition also reported hearing the rumbling of the coach wheels, the rattling of the harness and the prancing of the horses. Others reported seeing him with his dogs coursing in the fields. They had also heard him curse and swear. It was often said that he appeared as a large bird with sable plumage, not unlike a crow only larger, and would fly over his former estate, hover over the Hall then vanish. Another form in which he appeared was that of a shaggy foal and in this guise he paid his nocturnal visits, and paced the fields which he had possessed during his lifetime.

Heage Hall obtained such an awful reputation for being haunted that nobody possessing any degree of respectability would reside in it, and it was rented to two

notorious highwaymen called Bracy and Brackshaw who terrorised travellers in the vicinity. Because of their nefarious deeds, they probably nurtured the tales of hauntings to keep away inquisitive neighbours

Years passed and Edward Ridge became quite a changed man, silent and moody, with a permanent, scared look on his face. Instead of taking a similar position to the one he had held with Squire Pool, he bought himself a farm and took a young wife. It was only when he lay on his death bed, that he summoned his wife and made her promise to carry out his last wish. More afraid of meeting Poole than meeting his maker, he admitted to taking Poole's gold but wanted it all giving back to its rightful owners, Poole's two daughters. His wife promised to fulfil his last wish and pay the money back but as soon as Ridge was dead and she found the gold, she was ecstatic. Despite her promise, the last thing she intended to do was repay the money. She became a gay and wanton widow with a succession of applicants for her hand in marriage. She chose Daniel Hopkinson a local man of questionable ability and they lived a very colourful life squandered Squire Poole's gold until the last years of her life which were spent in miserable circumstances. Her sons did no better. They eventually lost everything and left the district, so everything that had ever belonged to the Ridges was gone and Poole's gold had never been restored. Is there any wander that the ghost of old Squire Pool is still said to wander his old home searching for his missing gold?

Plague Cottage
Eyam is famously remembered as the plague village when in 1665 the villagers isolated themselves to prevent the deadly plague that had been brought to the village from London, spreading to their neighbours. This was an act of true altruism by grief stricken people in a village where every home became a morgue and every resident a mourner. The cottage near the church where the plague began is known as Plague Cottage and like many of its neighbours, Plague Cottage is haunted.

In the 1970s the cottage was owned by Mr and Mrs Green who slept in the back bedroom until a time in 1978 when their grandson stayed. They put him in the front bedroom, but he was not happy. He woke to find a lady standing by his bed watching him before simply fading away.

He refused to sleep there any more and insisted on moving into the back bedroom with his grandparents, but because it would have been too cramped for three, Bill moved into the front bedroom. A couple of nights later, he saw the apparition for the first time.

Bill was a down to earth, level headed man who was not prone to exaggeration or inventive story telling, so naturally he thought he'd been dreaming. The next time she appeared in the doorway of the room, and being wide awake, Bill got out of bed and went towards her at which point she simply vanished. Bill had seen her clearly enough to be able to describe her as being neatly dressed with a pleasant face. She wore her hair curled under with a fringe in a style he could only describe as old fashioned, a fact that was emphasised by the plain style of her navy blue dress. After seeing her for the fifth time and having had his sleep disturbed so often, he refused to sleep in the front bedroom ever again.

Many of the plague cottages are haunted

Lowe Cottage – haunted house for sale

The Ghost with the Candle

A former vice-president of Holymoorside WI recounted how, as a girl, she had stayed with a friend at Birchover in a house that had formerly been an inn. During the night, they were both woken by a noise and saw a light being carried along the passage outside their bedroom door. The previous night, her friend's young brother had suffered from an attack of neuralgia and the girls assumed that it was he who had walked by on his way to obtain an aspirin. They called out to ask if he was alright but received no reply, so they got up to investigate and found him fast asleep in bed. No other members of the household had been awake until disturbed by the girls putting on the electric light, so who had walked along that corridor carrying what they had assumed was a torch, but could just as well have been a candle?

The Most Haunted House in South Derbyshire

Sometimes it is possible to experience every imaginable form of ghostly manifestation in one house, and Lowe Cottage is just such a place. It's an unremarkable, stone built, three storied property in Upper Mayfield, a tiny village on the border between Derbyshire and Staffordshire. It was once the servant's quarters to nearby Lowes Farm and retained some of the original features, a cooking range, oak beams and vaulted ceiling, sandstone frame-work and latticed windows.

In May 1994, Andrew and Josie Smith agreed to pay £44,000 for the property but could only raise a £41,000 mortgage. They agreed to pay the difference by instalments over the next three years to the owners, two sisters Susan Melbourne and Sandra

Podmore who had inherited from their father. Lowes Cottage had been their family home where they had lived from being small children.

What should have been a straightforward sale of property was soon to turn into a bench-mark legal case acted out in the full glare of the national media spotlight.

According to the newspapers, the Smiths had refused to pay a final instalment to the vendors because of the problems they claimed to have endured and as a result, the two sisters launched a county court action to recover the money due. In response the Smiths filed their own counterclaim in the civil courts for the return of £41,000 purchase price for not being told of the cottage's reputation for paranormal activity. A civil court in Derby was asked to sit in judgement and if the action against the vendors had been successful, which it wasn't, this would have represented the first time since the middle ages that a British court had recognised the existence of ghosts.

Andrew and Josie Smith claimed their ordeal began shortly after they moved into the cottage with their three children Linsey then aged twelve, Stephen five and one year old Daniel. They started to notice a horrible stench which seemed to move from room to room. The smell filled the house several nights ever week but checks on the plumbing drew a blank.

On two occasions Josie woke in the night to find herself unable to move, her body pinned to the bed by some invisible force.

The eldest daughter Lindsey experienced strange dreams and the apparition of a young girl in the cottage. During this early period the family found the rooms filling with a thick, heavy fog which was accompanied by an evil presence and dramatic sudden drops in temperature. On one occasion, Andrew ventured upstairs to confront the presence in a bedroom and was overpowered by a nauseating smell. He said 'The fog was so heavy I had a job moving my arms around and it was so thick you could lean on it. I could feel the atmosphere building up by the second and the room felt as if it was about to explode.'

After a year of living in the cottage, the couple approached a spiritualist church for help and brought in the Reverend Peter Mockford to bless the house. Temporarily this seemed to lift the oppressive atmosphere, then he placed his hands on the wall in the couple's bedroom and suddenly the walls started running with water. There were no pipes in that wall, it was a hot day, there was no puddle at the bottom and when the water stopped, the walls were dry in ten minutes.

Revd Mockford suggested that the family played religious hymns to exorcise the spirits, but the evil presence failed to respond to this idea. That night the couple were woken by a supernatural cacophony. This included the sound of the hi-fi system playing full blast while the immersion heater overheated and the cottage filled with a dreadful odour. The hi-fi could only be silenced when the plug was pulled and the next day it was found the fuses on the water heater had blown.

The following night, Andrew claimed he woke with a jolt to find Josie lying on her back with her mouth wide open, kicking her legs violently in the air as if something was throttling the life out of her. She struggled for ages until the spirit left her, then Andrew heard something going up the stairs and it gave a terrible groan that made his hair stand on end.

On one occasion, a neighbour claimed a disembodied spirit passed through his body during a visit to the house.

During their four years at the cottage, they had endured poltergeist manifestations of objects flying through the air; heard deep groans, creaking floor-boards and footsteps; failing electrical equipment, acrid smells and sudden, inexplicable drops in temperature. Josie claimed she had seen apparitions of a bound, naked woman, a little boy with piggy eyes and a woman in nineteenth century costume. The family periodically left the house to escape the hauntings, sleeping on the floor of Andrew's mothers two-bedroom flat. On one of these occasions, the family returned to find their two pet budgies dead 'their faces pressed against the cage in identical positions.'

The priest suggested that in order to put the spirits to rest, they should be identified. This led to a search through records and an appeal to folk memory. They heard that a young milkmaid called Ellen had been imprisoned, abused and murdered in the cellar of Lowes Cottage in the nineteenth century. Searches in the local record office established that a fifteen-year-old-girl called Elaine Harring had indeed lived in the servant quarters which became Lowes Cottage in 1861.

Also there was a vague story about a young boy who was reputed to have hanged himself from the rafters. Could this be Joseph Phillips, identified as a cow-lad at the farm? There was no record to suggest a murder or a suicide had befallen either Elaine Harring or Joseph Phillips, but unconvinced, Andrew began to dig up parts of the garden believing they could have been buried there. He found nothing.

In May 1998, two ghostbusters from Ashbourne visited the house in an attempt to find evidence to back up the couple's claims. Their recording equipment picked up a odd male voice and their infra-red camera picked up a strange white mist that engulfed one of the bedrooms. By 1998 when the family moved out, the cottage had been exorcised five times by a Church of England priest who has described it as 'a demonic house – the most severe case he had ever been asked to deal with'.

But the evidence was considered insufficient at the January 1999 court hearing. Judge Peter Stretton in his scathing ten minute summary of the case said 'this house is not haunted and never has been haunted. The noises, damp and smell were more likely to be created by man than by ghosts.'

The Lowes Cottage case was in fact the latest in a series of courtroom findings which have highlighted the reluctance of the judiciary to rule upon the existence or otherwise of the supernatural. In 1989, a council-house tenant in Nottinghamshire sought a judicial review to the local authority's decision not to re-house his family who claimed their house was infested by a poltergeist. In New York however, the existence of ghosts has been legally established as a result of a court ruling. In 1991, the State Appellate Court set a legal precedent that vendors must inform potential buyers if a house is haunted or face having to return the deposit.

The Smiths subsequently put the cottage back on the market at £50,000 with no reference to any hauntings in the estate agent's literature, and in April 1999 it was bought by London businessman Tim Clinton who is also a member of the Churches Fellowship for Physical and Spiritual Studies who paid £56,000. Mr Clinton has promised a fresh start for any troubled spirits that might be hanging around.

Surgical Spirits

On 1 April 2010, the Queen officially opened Derby's New Royal Hospital and the occasion went without a hitch despite it being April Fool's day and the fact that the newly built hospital had gained a lot of earlier, unwelcome publicity. Apparently this state of the arts hospital is haunted and the fact is causing great concern and disruption amongst the staff.

This first came to light in the summer of 2009 when an email sent by senior manager Debbie Butler was leaked to the media. She wrote – *'I'm not sure how many of you are aware that some members of staff have reported seeing a ghost. I'm taking this seriously as the last thing I want is staff feeling uneasy at work. I've spoken to the Trust's chaplain and she is going to arrange for someone from the cathedral to exorcise the department.'*

Workers at the newly built hospital have reported seeing a dark figure in a black cloak stalking wards and corridors, and a hospital spokesman has confirmed that a number of hospital workers have been spooked by the sightings. The £334m hospital is built on the site of the old Derby City Hospital on the west of the city just off the A516 Uttoxeter Road, but it seems that when the old hospital was built in the 1920s, developers ignored local protests about the construction and covered over part of a Roman road. So could this latest inmate at the new hospital be a 2,000 year old Roman soldier? That's what the experts seem to think

As it had previously been the site of the city hospital, I was intrigued to know whether staff there had been aware of this particular spirit, and found rather surprisingly that he's never had a mention. There's the story of a couple who got into a lift with a little girl who was described as skipping along beside them until she simply disappearing. Nurses had reported seeing staff from another time and era hard at work. A porter saw a nurse who he knew had recently retired, but when he mentioned this to a nursing colleague he was told that was impossible. A short time ago they had heard that this ex-nurse had just died of a heart attack. There was a resident ghost who wandered along the corridors and was often seen through glass doors but his description was hazy and certainly not that of a Roman centurion.

Hospitals seem to have their fair share of ghostly spirits, perhaps because such places have a highly charged emotional atmosphere and have inherited a permanent reminder of the suffering and death of many patients. Hospital staff and former patients often experience images of past events and many accounts are uncannily similar. For this reason and because some of these Derbyshire properties are still in use, the stories are generalised to conceal their identity for the peace of mind of new patients, as some paranormal activity is still being experienced to this day.

Inexplicably blocked doorways are a regular occurrence. There are doors that seem unaccountably stuck then are suddenly free, and fire escape doors that burst open of their own accord. There are visitors that step into lifts and vanish, patients that shouldn't be there, and staff from another time and era who seem to be hard at work. Things get moved around, things go missing then turn up later, yet no-one is responsible. Porters and members of staff regularly report trolleys being pushed by unseen hands, and hearing the distinct sound of footsteps ascending or descending

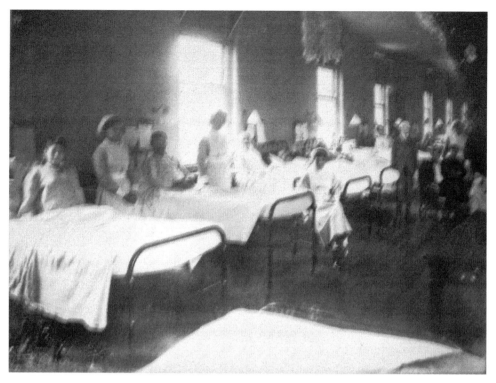

Above and below: Nursing staff often return in spirit to their former wards

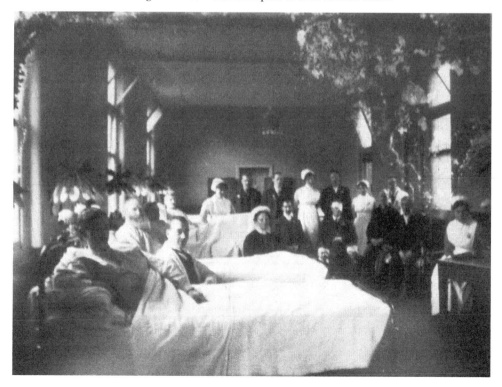

spooky stairwells and walking along creepy corridors. After the death of one patient, for quite a lengthy period the familiar and distinctive pattern of his footsteps were frequently heard shuffling around his former ward.

Many nurses have sensed strange atmospheres and there are numerous reports of bizarre happenings on wards. A former nurse recalls how around 4.30 a.m. one morning, the sound of voices brought two members of staff out of the ward office to investigate. The talking was coming from the end bed where to their disbelief hung a misty cloud. Although no doors or windows were open, as they approached the mist quickly disappeared and the nurses found that the patient was dead. It is believed that in our dying moments consciousness begins to drift to a higher level of existence. The person then passes out of the physical body and into the etheric body, a process that is sometimes witnessed as a silver thread or mist rising from the physical body. The spirit will then linger by the body for a short while before casting off the etheric body and moving into the spirit world.

A nurse reporting for duty noticed a naval officer sitting beside one of the beds. He gave her a sad smile and although it was well past visiting hours, the nurse didn't bother him as the patient was very ill and not expected to live through the night. She returned the visitor's sad smile. Carrying on with her duties, she went to check on the patient a little while later and found his condition had deteriorated further. As there was no sign of the visitor, she asked her companion where the visitor had gone. The girl replied that she had not seen him since they had come on duty. At about 2.00am. the nurse noticed the visitor again and she realised that the uniform with its tasselled epaulettes was not of this era. She walked towards him, but the figure melted away as she approached. Later that night, the patient died.

While sitting at her desk, a nurse on night duty caught sight of an elderly female patient walking down the ward. Thinking that she was confused and wandering, the nurse went to escort her back to bed, but as she approached the woman just disappeared. One nurse saw a patient near the far end of the ward pulling on a dressing gown. She walked briskly over to see why the patient was out of bed, but the figure just vanished.

One nurse described a night when the sound of running water was suddenly heard. On investigating, a sluice room was found to be the source with its taps fully on although no-one had used the room that evening. Having turned off the water, the nurse reported to the sister who simply smiled and said, 'Oh it sounds as if she's up to her old tricks again.' Apparently, a former nurse committed suicide after the death of a child in her care and her ghost now returns to turn on the taps and occasionally turn off the oxygen supply.

There are reports of other former nurses returning to check on their patients. One, described as a golden haired girl is regularly reported leaning over a particular bed, and three young men who were convalescing watched a nurse in a long grey dress as she drifted between the beds then walked right through the fireplace. A lady recovering from a serious illness woke one night to find a nurse standing at the bottom of her bed. Thinking it was the night nurse, she simply turned over and returned to sleep, yet next morning she remembered the butterfly-type cap she wore on her head. When she enquired who it had been, she was told that it was a former ward sister who had been killed when the hospital had been heavily bombed. She regularly returned in spirit to her former ward and had been seen by a number of people.

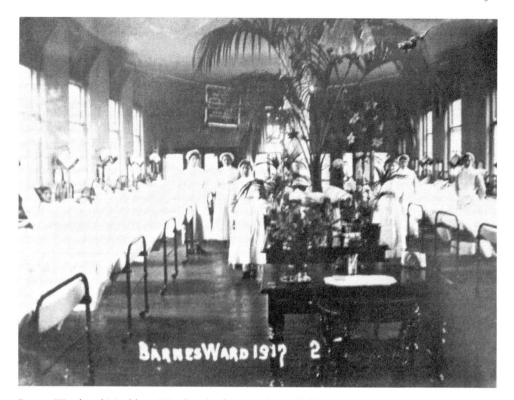

Barnes Ward and Markham Ward at the former Chesterfield Royal Hospital, 1917. Do these nurses return in spirit?

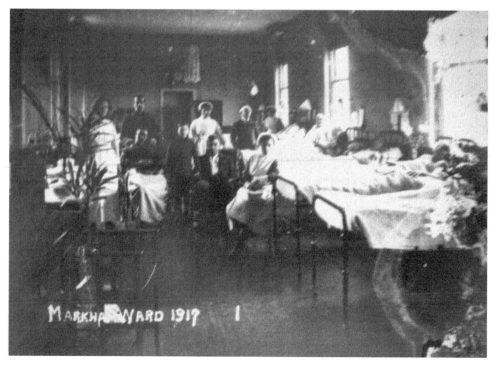

A porter at one of the hospitals was about to take someone into the morgue to identify a dead relative, but decided to check the corpse first. He walked into the morgue, but was amazed to see a young man sitting on one of the two trolleys.

'What are you doing in here?' he asked in astonishment. The man just grinned then appeared to float away from the trolley and straight through a wall. The porter resigned his job immediately as he could never face entering the mortuary again.

Many of the old hospitals with their grim Victorian façades were originally built as workhouses for the destitute and are now largely disused. At the Derby Manor Hospital a plumber working on a radiator in the toilet block at the far end of Northmead Ward watched in disbelief as the lid of a waste bin lifted slowly then banged down. Ward Six had been closed for repairs and redecoration during which the ward was securely locked when the workmen were not present. One night, staff on Ward 8 which was directly above were concerned about the amount of noise coming from the locked ward, so a nursing sister went to investigate. Although she saw nothing, suddenly she was struck on the shoulder by a flying object which hit the floor and rolled under a bed. She found that it was a glass medicine bottle which despite the impact was undamaged. The sister was rather freaked by this and left hurriedly, but early next morning she returned to the ward. The bottle had gone and was never seen again.

Some former hospitals like the old Royal Hospital at Chesterfield find a new lease of life as the headquarters of a car-hire company, but others like Grove Hospital in Shardlow have to face the bulldozers. That's when things really start to happen.

Workmen on the site at Shardlow claim to have seen ghostly figures flitting through former wards, felt icy blasts and heard strange bangs. Demolition expert Phil Massie, site manager for Carwarden Demolition of Ockbrook, Derby led the team of workers who felt that the supernatural goings on must be because ex-patients did not want the hospital to be knocked down; so were the demolition team facing a protest with a difference? Were a number of disgruntled and bemused ex-patients of the former Grove Hospital demonstrating from beyond the grave?

At first the men ignored the inexplicable bangings, the grey mist that covered part of the building and the icy blasts that gusted from no-where.

'I am not a great believer in this kind of thing but there is definitely something that is not quite right,' said Phil. 'The more work we do, the more things seem to happen. Some of the lads saw what they thought was someone walking past and concerned for the safety of a member of the public, shouted out a warning. They went to check where the person had gone, but there was no-one there.'

The building was last inhabited by patients in December 2005, but it would seem that some are still residing there – at least in spirit. In 2006, a group of ghost hunters did a nightly vigil in the empty shell of the ex-hospital and captured a number of orbs on camera.

Some orbs were floating down the empty corridors, others hovered over seating, particularly in one of the former day-rooms. Members of the group made spirit contact with a lady called Elsie or Goldie. She was sitting in a chair watching what was going on with interest.

The group recorded similar experiences to those experienced by the workmen, and local psychic Jason Daine was called in to investigate. He claimed that he was able to talk to a number of disgruntled and bemused ex-patients.

'These people are between our world and the next,' he explained. ' I was speaking to a man called Henry who was being sick in a sink in one room. Then a lady called Claire told me she was born in Derby and she was taken to hospital because she was too ill to be left on her own. There is certainly plenty of activity here.'

Grove Hospital was in the grounds of the former Shardlow Workhouse which was erected in 1816. Following reconstruction work, it re-opened in 1970 to care for elderly patients recuperating after treatment elsewhere, then closed in December 2005 with its patients transferred to a new £15 million building at Derby's Royal Infirmary. In 2006, developers Miller Homes bought the site from Derby hospital's NHS Foundation Trust for more than £2.5 million and permission has been granted to build fifty-nine houses on the land, but will the former residents approve?

Earth Energy

There was once a widespread belief that everything in nature harboured elemental spirits, and under the collective title of nature spirits they all needed placating with offerings and sacrifices, so our pre-Christian ancestors practiced a series of animistic rituals. These beliefs were at one time so widely acknowledged that the Council of Tours in 567 declared that those who worshipped trees, stones of fountains should be excommunicated, but the pagan animistic tradition of worshipping natural deities continued despite all attempts by the early church to stop it, and knowingly or otherwise, we still practice some of them today.

It was thought that a nature spirit resided in each field of corn, so at harvest time, the last sheaf was cut with great care in order to preserve the spirit of the corn. This was then made into a corn dolly – the word dolly is derived from the word idol. The spirit was preserved in the dolly during the winter, then in the spring, the dolly was broken up and mixed with the seed corn in order to transfer the spirit back to the soil to ensure a good harvest. This form of animistic rituals is still practiced today in many areas.

Water Worship
We can't see the water spirits or undines that live in all bodies of water from wells to oceans because like all nature spirits they blend into their surroundings. Our ancestors believed that if the water spirits were appeased by the correct propitiatory rites and sacrifices at the appropriate time and place, the water would continue to flow, and that was vital. Early hill settlements were invariably sited where one or more springs emerged, but if the spring failed so did the village economy, and life itself was in jeopardy.

The importance and scale of Celtic water sacrifice was phenomenal. As well as the fresh water springs, the lakes, rivers and wells were considered sacred places, confirmed by the many votive offerings since found in them. As much as 50 tons of gold and a similar amount of silver, looted from sacred water sources in Britain alone cleared the Roman Emperor Caesar's vast debts and financed his career.

Few of us can resist the urge to throw a few coins in a wishing well, but how many of us realise we are actually following the ancient rite of making an offering to the water

spirit? It may not be a ceremonious ritual, but it's based on the same principle – we are asking the water spirit, in return for our offerings to implement our wish.

White Ladies

But it wasn't just coins, jewellery and metalwork that was used as offerings by the early Britons. Goods and people were sacrificed in bogs and pools until the early centuries AD. Animals and humans were dedicated to the gods and many people believe that this could be the origin of White ladies who are perhaps the most regularly seen ghost manifestations. The term comes from either the colour of their attire, a white shroud or because they seem to exude a radiance or glow from their ghostly, diaphanous bodies. A number of theorists place this gentle, archetypal feminine figure as a form of 'genus loci' or 'spirit of place' linked with certain landscapes. What is not in doubt is the connection between this kind of ghost and places such as rivers where waters meet and merge, and at bridges or fords which symbolise boundaries of life and death. It was at these watery places where the pagan practice of sacrificing a suitably attired virgin was performed (white is used to mean holy) in order to placate the water god and ensure a plentiful supply of fresh water.

Ghostly white ladies could have been sacrifices to the gods

The statue of Arnemetiae – later Saint Anne (Buxton Museum)

At Castle Gresley when fog or mist hangs in the air, a ghostly white lady is said to appear on the outskirts of the village near a reservoir supplied by a spring named White Lady Spring. Anchor Church which for many years was the home of a hermit, is a natural cave hewn out of the rocks by the side of the River Trent at Ingleby. A feeling of calm emanates from the walls, and the floor bears indentations associated with the signs of kneeling for daily worship. It is also the abode of many unsettled souls including a hermit, a wandering monk and a lady in white who glides along the river bank. It's possible that this pure, young lady was sacrificed to the river gods, then compelled by Druidical magic, she protects the place she gave her life for.

When the Romans conquered, water worship was strictly forbidden, but people still wanted to give thanks for the precious gift of water. Human sacrifice was no longer permitted but votive offering like garlands of flowers were used to dress the wells and the practice was absorbed into Christianity with a few adaptations. Water worship in the form of well-dressing, then continued but under the patronage of the church.

There was an important shrine at Buxton's thermal spring where the Celts worshipped a water-goddess called Arnemetiae 'the goddess beside the sacred grove'. In Roman times Buxton became second only in importance to Bath for the curative quality of its water and in order to bend the rules to fit, the goddess Arnemetiae became Saint Anne.

Well Dressing is carried out at many Derbyshire villages

Well Dressing in Tissington can be traced back to 1350, when neighbouring villages were hit with the deadly plague. Tissington alone remained immune and this was credited to the purity of their water, so the village wells were dressed in thanksgiving. Other white peak villages followed suit and Derbyshire is now the only place that has continued this beautiful old custom. Throughout the summer months, forty plus villages and towns throughout Derbyshire dress their wells, springs and more recently taps in the old tradition using flowers and other natural objects to form pictures.

Spirit in the Stone
Our ancestors believed that the spirits that resided in rocks and trees also had special powers, a conviction that is so old and so universal that it can't be dismissed simply as ignorant superstition. When lovers carve their initials within the shape of a heart on a tree trunk or rock, they are following an ancient custom, and knowingly or otherwise asking for the blessing of the nature spirit that resides within.

The young men of Baslow went one step further. They had to, because at one time, the girls of the village would not accept the advances of any young man unless he demonstrated his manhood by scaling the awkwardly shaped boulder known as the Eagle Stone located on Baslow Edge. The climb, performed almost as a right of passage, was done amongst much ceremony, and any man managing to climb to the summit of the rock was believed

The Wishing Stone at Lumsdale

to receive the blessing of the nature spirit that inhabits the Eagle Stone. It's only when you questioned the name Eagle that you realise how significant this stone actually is, because whichever way you view it, the Eagle Stone has none of the characteristic features of an eagle. In fact, anything less bird-like than a solid clump of rock would be hard to imagine until you realise that Eagle is a corruption of Aigle (and translated from French), and Aigle is the name of the Saxon god who could throw stones that no mortal could move. Presumably it was hoped that in exchange for this show of pubescent bravado, the nature spirit would reward the young men with some of Aigle's mighty strength.

Another significant stone is the Wishing Stone located at Lumsdale near Matlock which was enormously popular with the Victorians, who were great advocates of the power of nature spirits. They believed that the spirit that dwelt in this particular rock, could grant a wish. Apparently it is necessary to walk round the rock three times while repeating the desired wish under your breath. If the spirit favours your request and your wish is not for materialistic gains, it will come true within the next three lunar cycles, so have faith and good luck! In romance as in any other endeavour, confidence and conviction play their parts.

Divination with Stones
Stones also had a part to play in divination arts. On Hallowe'en, each person present would scratch an identifying mark onto a white stone, then cast it into a blazing

bonfire. The next day they would search for their stone amongst the ashes. If the stone was there, undamaged it was a good omen for the next year. A missing, cracked or otherwise damaged stone was a bad omen.

Pessomancy is divination by drawing or casting specially marked stones – known as wise stones, to foretell the future. If you like the idea of making your own wise stones, select nine stones, small enough to fit in your hand and mark each with an appropriate sign or word. Concentrate on your question as you shake the stones in your hand, then cast them in front of you. The answer to your question can then be read in the stones. Those nearest to you represent the near future, those furthest away foretell the distant future; stones touching should be read together.

The Power of the Stones
When horses were found sweating, exhausted and frightened in their stables in the morning, it was automatically assumed that they had been hag-ridden by witches. To protect against this, a stone with a natural hole eroded by the elements, was hung over the stable door. As witches were often referred to as hags, this was thus called a hag-stone.

A hag stone was prized for its intrinsic powers. People used them for luck and to protect their home, family, trade or stock against witches and malignant neighbours. They hung them round their necks or tied them to a key as a symbolic gesture of protecting the entrance to the home, and hung them over their beds to protect them from nightmares, demons and witchcraft.

It is said that if you hold the stone up to the full moon and peer through the natural opening, you will be granted visions of events that are yet to come.

A number of larger holed stones around the county have local traditions which claim that they were useful for healing various ailments. Where the hole is large enough to crawl through or pass a child through, this action was reputed to effect the cure of such ailments as scrofula, rickets, whooping cough and epilepsy.

This is just part of the folklore of prehistoric sites, the study of which is called stone lore. Derbyshire is fortune to have the littered reminders of many ancient stone circles and burial mounds, and it is said that the stones at such sites have much in common. Originally they were sacred places where the milestones of a person's life would have been celebrated – religious ceremonies, rites of passage, rites connected with childbirth, puberty and marriage as well as death. The stone circle acted as a mystical wall, to contain the magic of the occasions while excluding everyday life.

A core element of many ancient, sacred henges and monuments was the astronomical aspects that were built into their structure. These orientations linked them with the heavens and surrounding landscape so that the midwinter sun would shine directly down the entrance passage or along the main axis. Some central gap usually framed the midsummer sunrise or other significant lunar event. This association with ancient astronomy is one of the reasons why traditional festivals that reach back to pagan origins still take place at these sites. Such festivals relate to the astronomical divisions of the solar year – the solstices, equinoxes and the 'cross quarter' days between. These are Imbolc (February), Beltane (May), Lughnassadh (August) and Samhain (November).

Over on the west of the county is the great henge and stone circle at Arbor Low near Monyash. It is one of the finest examples left by early man, and has become known as the Stonehenge of Derbyshire. Low comes from the old English word 'hlaw' meaning high hill and usually depicts a site of pre-historic significance.

Modern day witches with their respect for nature still meet on Stanton Moor and report a strong energy force in the area of the Nine Ladies Stone Circle. According to legend, the devil played his fiddle while nine ladies danced on the Sabbath, but God was so furious at their transgression that he turned them all into stone for disregarding his holy day. It's a story that is attached to many similar stone circles, but instead of being called ladies, they are called 'maidens' which is believed to be a corruption of 'meyn' meaning stone, so this may be inchoate folk memory and over time was changed to ladies. Stanton Moor is rich in stories that include abduction by UFOs, spectral black dogs, ghostly monks, headless horsemen, a green man, a white lady and hovering lights. Another remnant from the past is the votive or rag tree on Stanton Moor, which is still used today. (See Mystical Trees)

Ley Lines – Earth's Invisible Power Source
In June 1921 Alfred Watkins rediscovered leys. Many people said he actually discovered them, but that is not so – it is possible that they were recognised in Britain in the Neolithic period roughly 5000-2000 BC. Watkins realised that the ley lines were sited from one hilltop to the next in alignment, linking ancient Celtic or Druidic points of worship. Derbyshire's Arbor Low and the Nine Ladies Standing Stones remained sanctified pagan sites while other locations were later Christianised by having a church or cross superimposed on them. With fallen stones and modern obstructions this line is now impaired but if you look at a Derbyshire map, you'll find that Arbor Low, Stanton Moor and the Fabric, once a Druid temple site 980ft above the village of Ashover, all sit on the same line.

Leys are well submerged both actually beneath accretions of buildings and earth, and metaphorically beneath layers of time, so what made Watkins findings so fascinating was his pronouncement that these leys were in fact energy channels, and where they cross, powerful forces are concentrated. With this discovery came the realisation that ancient man didn't just erect monuments on any old hill, he knew how to tap, argument and utilise these earth energies.

The tribal shaman experienced visions and used intuition rather like the mediums and psychics of today, so if a shaman recognised some location as special, a place where the energy was at its strongest, the whole tribe would take note and the ancient markers such as stone circles and megaliths would be focused there so that as they worshipped, the people could benefit from the earth's power. Many people have experienced a sense of languor at these ancient sites and it has been suggested that perhaps it's the heightened natural radiation that can engender this feeling. If this is so, it is possible that this factor was used by our ancestors to help promote ritual sleep at these sites.

The fact that some invisible force spider-webbed the British landscape with lines like some Neolithic energy grid understandably caused quite a controversy and all kinds of

The normally invisible vapour that rises from the stones

Tentatively testing a stone at Arbor Low

new theories began to surface. It's been claimed that these unusual energies leak from the earth at suitable release points to be seen like a transparent heat haze that sprays into the air before dispersing and disappearing.

At its most powerful, this energy leaks out into the atmosphere creating visual changes in the air which creates radio and TV interference, power overloads, and temporary disruptions to street lighting. Sometimes this causes particles to be charged and transformed into glowing effects in the atmosphere rather like disco lights (see Earth Lights).

People who are particularly sensitive to changes in atmospheric pressure report hearing faint sounds like whining, humming or buzzing much like those emitted from transformers and power lines. All the stones at these sites are believed to hold electrical energy which can be harnessed in many different ways. Some people who touch the stones are able to feel the energy and there are even claims that it is possible to get a mild electric shock. These geophysical conditions might also affect the subconscious mind which may account for the idea that these stones can aid conception and act as a powerful healing element.

Psychometry or Psychic Archaeology
Electrical energy is an invisible force believed to surround and permeate all things, and psychics believe that any inanimate object can pick up and store the energies of

a person or event that has been associated with them. Psychometry is the technique of tuning into these energies, and a psychometrist is able to deduce facts about events by touching objects related to them. They can tune into the vibrations of an item and detect the circumstances surrounding the individuals who have had immediate contact with it.

The technique is usually demonstrated when the psychometrist is given a personal object like a watch or ring, and by tuning into the electrical energies, can give information pertaining to the owner.

When this same technique is applied to buildings or other structures like ancient standing stones, it is called psychic archaeology While touching ancient stones it is possible to be taken back to the times when these places were inhabited. This usually takes the form of thoughts and feelings from those who have been associated with them.

The sceptics will remind us that such material can't be checked, and in the cases where it can, its highly possible that the psychometrist has actually obtained the information by normal means, so it's a no win situation. Despite this, psychometry remains popular and explanations as to how it works keep being offered though none give a fool-proof answer.

Gargoyles
Stone is used to sculpt all manner of things both functional and decorative. Although the gargoyle is meant to serve both these factors, it is hard to imagine anything more grotesque than those carved stone figures that adorn countless churches and other buildings to drain rain water from the gutters. They tend to sit on their haunches on

Cursed stone heads

the parapet of buildings projecting out several feet so that the water is spouted out well clear of the base of the building. Perched up there, they seem quite harmless, and after the introduction of the lead water pipe in the sixteenth century, quite useless, but many are supposed to come alive at night and fly around.

A man was walking home through Derby late one night when, out of the corner of his eye, he caught a movement of something flying high above him. It was too big for a bat and too dark for an owl and as the mystery creature landed on the pavement ahead of him, to his horror, he realised that he was surveying something that could only be described as gargoyle-like in appearance. The face was leathery, the set of its eyes were hollow and unblinking, and the mouth agape with fanged teeth. Its wings remained half-spread before it sprang upwards and disappeared. The following day while walking past St Michael's church, he looked up and there on each of the four corners was a gargoyle – a lion, an angel, a bull and an eagle that looked remarkably like the creature he had seen the previous night.

Cursed Stone Heads

Despite the previous story being modern, it smacks at the kind of stories that our ancestors linked with these stone carvings. Many were believed to be cursed and brought such mischief and bad luck that they became known as cursed stone heads.

A man who unearthed one at Marple gave it to a friend who suffered a number of heart attacks. The friend returned the head which was then taken to the owners workplace. Its arrival coincided with so much illness and misfortune, it left his staff in a state of terror, and eventually it was taken to a museum. But the story of the Mouselow stones is perhaps the best example of cursed stone heads.

In 1846, these stones were taken from Mouselow Hill, just outside Glossop by a local vicar, and bricked into a house wall before being removed and taken to Buxton Museum for safekeeping early in the twentieth century. They are pre-Roman, of cult significance and may have once been part of a religious shrine.

There were about ten carved stone heads, some with typically Celtic, bulging eye style heads, strange shadow figures and a crude representation of the horned god. Some are carved with letters, fertility and other strange symbols which have been recognised as representing the river of life, the wind blowing from the four corners of the earth, gods, and other objects that the Celts worshipped.

A number of other stones, including Celtic style stone heads, were subsequently added to the group and in 1985, the stones were returned to Glossop to coincide with a three year archaeological excavation on Mouselow Hill, near the site where they had first been found. A local woman called Glynis Reeve who was in charge of the dig, decide to displayed the stone in Glossop Heritage Centre in order to gather information about them. She was unprepared for the feelings of fear and dread they aroused amongst local people who considered them to be quite evil. There were numerous anonymous phone calls warning of curses, and there were so many unexplained accidents and injuries that the site excavation was temporarily halted.

Electrical equipment refused to work when placed near the stones, and when it was time to move them, they had to be stored overnight in a room containing a number

of computers which suddenly stopped working. Checks with the electricity supply found there was not a power cut as originally suspected, and technicians who checked the computers could find no reason for the failures, but when the stones were finally returned to the museum, the computers began working again.

A member of staff at the museum admitted that he had been told the stones had very powerful magnetic properties, but he dismissed this as a piece of folklore. He was proved wrong.

Stone Heads & Skulls

Grotesque stone heads are a common sight in the Pennines, incorporated into the fabric of churches, farmhouses and walls. Although they could have come from even earlier structures, churches from the eleventh and twelfth centuries have an abundance of them with their staring, bulging eyes in gargoyles, horned men, mouth pullers, tongue stickers and strange animals. Many are representations of forgotten gods and goddesses which is why historians claim that some of these stone heads with expressionless faces that gaze out from buildings could be 2,000 years old.

That means that these stone heads were the handiwork of the indigenous Celtic tribes and may have been of cult significance because the Celts were well know for their veneration of the human head. According to the Greek writer Diodorus Siculus, the Celts cut off their enemies heads and hung them above the doors of their huts, displayed them on poles, or hung them around their horses necks as grisly trophies of war. They believed that the human spirit lived in the head and by displaying the heads they could prove that they had not only captured their enemies body but also his spirit. On Hallowe'en or Shaim Armein, the spirits become free, so to entice them back, a lighted taper or candle was put inside the skull. This is the derivation of the Hallowe'en pumpkin, hallowed out and cut to represent a skull with a candle burning inside.

After the arrival of the Romans the taking of real human heads was outlawed but the significance of a head as a magical talismans to bring luck and avert evil continued in the sculpting of stone heads. As well as empowering them with positive attributes it is not so unlikely that the native Celts could have also empowered them with negative ones too, so cursed stone heads were a means of promoting fear in their enemies and simple people.

A whole package of folklore and superstitions have become woven around the human head. Ashbourne's annual Royal Shrove Tuesday Football game is so old there is the macabre theory that the ball was originally a severed head tossed into the waiting crowd following an execution.

Stories of headless phantoms are told throughout Derbyshire. Some of these decapitated wraiths could date back to Celtic head veneration. Archaeological excavations of numerous Pagan, Celtic and Saxon burial sites reveal that the remains of the interred corpses had their heads placed between their knees or feet. Another reason could be that in later centuries, many people were beheaded for political crimes against the monarchy, and in the Civil War, Cavaliers had their heads removed to make sure their bodies could not be identified and didn't fall into the hands of their enemies.

The human skull was particularly valued not least for its power to cure all ills.

The Hallowe'en pumpkin represents a skull, and the burning candle is intended to entice the spirit back

Skulls were also used in many cures. Ignoring the fact that it must have been leaking like the proverbial sieve, water drunk from a skull was believed to be very beneficial for numerous medical problem. Powdered or grated skull bone was mixed into food and eaten to cure epilepsy, headaches and plague. Moss scraped from an old skull was said to staunch bleeding of a wound or a nose bleed. If dried, powdered and taken as snuff it was believed to cure a headache or act as protection against the plague. A person bitten by a mad dog was advised to take pills made from the powdered skull of a hanged man.

It was once the fashion to display skulls in old houses in the belief that they must never be taken away or bad luck, illness or even death will follow. The best known examples in Derbyshire are a skull that was kept on a window sill at Dunscar Farm on the slopes running up to Mam Tor near Castleton, 'Dicky' at Tunstead Farm, tucked under the escarpment of Ladder Hill overlooking the Combs reservoir, and the Flagg Hall skull that is even included in the house's valuation.

Tenants who treated the skulls with respect found them to be talismans against evil and hardship, but if they were discarded, cattle strayed or died, crops failed, and accidents happened. Many calamities could be credited to human error, yet the frequency and regularity of bad luck and misfortunes that happened when the skulls were disturbed were more than just coincidental.

Skulls were used as good luck talismans, and powdered to cure all medical problems

The Power of Trees

The association of trees with wisdom and knowledge was once very common and trees have always been part of religion. The image of white clad Druids performing their rituals deep within a forest glade is not entirely unfounded, for the Druids worshipped the spirits of the trees. Their temples were the sacred oak groves and the name Druid is said to translate as 'knowing the oak tree'.

It was an ancient belief that trees were inhabited by the gods who gave them powers to foretell many things, and from the early Druids onwards, wise men would sit under specific trees and interpret the rustling of the leaves and other subtle signs as oracular messages.

The Oracle Tree at Hassop Hall

Hidden away behind a tall garden wall in the tranquil village of Hassop between Bakewell and Calver is Hassop Hall. It's now a very popular country house hotel but the recorded history of Hassop reaches back 900 years when it was the principle residence of the Foljambes who remained until the end of the fourteenth century. At the close of the fifteenth century, Hassop came into the ownership of the Eyre family, until the late 1850s when inheritance of the estate became a contested affair. Over the next few years, numerous claims were refuted and during all of this time, tales circulated about the old beech tree that stood in the grounds of Hassop Hall was an oracle tree, able to predict the name of the rightfull owner.

It was said that when the wind blew from the west, the Hassop beech tree would whisper the name of the rightful owner of the Hassop estate and the words – 'All Hail, true heir that stills my voice.'

With so much at stake it's not surprising that various would-be owners tried to chop it down, but no sooner had they lifted the axe when some weird, unfortunate accident occurred. One man alleged that the tree warned that the house itself would fall if the tree was ever cut down by human hands.

Ultimately, a combination of age and weather tore down the tree, but the ownership is no longer in question. It has been in the hands of the present owner Thomas Chapman and his family since 1975.

The Mandrake Tree

Until a storm in December 1883 ripped it from the ground, a mighty oak tree stood in the grounds of The Hagge, a sixteenth century house at Handley near Staveley. It was believed to have been planted during the reign of Henry VIII and stood for 360 years although in its latter years it had to be propped with timber and buttressed with earth banks. It was known as the Mandrake Tree or the Haunted Oak and was venerated by local people who considered it to be supernatural. If it was damaged in any way, it let out an awsome half-human shriek, and if it was broken or cut it bled a thick red liquid resembling real blood. It was said to be the only oak tree in the county to bear mistletoe and apparently a supernatural voice was heard to issue a warning that the house itself would fall if the tree was ever cut down by human hands. In the end no human hand was involved and the house was spared.

The Protective Yew

Yew trees are frequently associated with churchyards as prior to church building, these old trees marked significant pagan meeting places and grew on sacred sites where the first missionaries preached the gospel, and couples were betrothed. Long lived and evergreen, the yew was seen as a symbol of immortality, and has long been revered for its ability to protect against evil. Sprigs of yew were once put into a dead person's shroud, and branches were carried by mourners before being put into the grave to keep the devil out and to prevent the soul of the dead from escaping. But beware, disturbing a graveyard's flora is believed to attract great misfortune.

It is said that in the fourth century, a recently converted army chaplain, after baptising convents in the River Derwent beside Duffield church, noticed that they then touched the Yew tree in the churchyard. Recognising this as a pagan custom, he baptised the tree too.

In St Helen's churchyard Darley Dale, north-west of Matlock is the oldest, largest yew tree in Derbyshire, estimated as being between 1,000 to 4,000 years old; (obviously can't be too accurate when dating yews). Its gnarled trunk is 33ft (10 metres) in circumference.

Standing beside Doveridge's thirteenth-century church of St Cuthbert, is another remarkable, ancient yew tree conservatively estimated at being a thousand years old and thus the second oldest in the county. When last measured, the trunk which is now

Robin Hood was
bethrothed under the
Doveridge Yew

hollow, was 22ft in diameter and the outermost branches were found to encircle an
area with a perimeter of 260ft. Despite the fact that the gnarled arthritic branches of
the Doveridge yew are now supported by sturdy props, it is still full of foliage and has
a special place in our Derbyshire folk lore because it was under the Doveridge Yew
where Robin Hood was betrothed.

Betrothed Under the Yew Tree

Many historians claim that Robin Hood was a myth, a quixotic story invented to
entertain, but fact or fiction, the stories of Robin Hood are widely known. Helped by
a band of merry men, Robin robbed the rich to help the poor and although stories of
the adventures of Robin Hood are long and legendary, unfortunately tales of romance
took a back-seat. The love of his life was always portrayed as Maid Marion, yet in *A
New Ballad of Robin Hood Showing His Birth, Breeding, Valour and Marriage* housed
in the British Museum, he takes a lady called Clorinda to be his wife and they are
betrothed in the shade of the Doveridge yew.

Mary Bray, the Ashford Dwarf who was believed to be a witch who married couples over the broomstick (courtesy of Derbyshire Local Studies)

Married Over the Broomstick

The broomstick is a traditional symbol of womanhood yet in folklore it is associated with mystical powers and witchcraft. Jumping over the broomstick was a well known wedding custom which survived until fairly recently in rural Derbyshire.

Mary Bray has been given the name the Ashford Dwarf as she was apparently only three feet tall (90cm), and the villagers believed her to be a witch. During the latter half of the eighteenth century 'Owd Molly Bree' lived in a thatched cottage, opposite the church in Ashford in the Water. She intimidated her neighbours and was an object of fear and ridicule to the children but she obviously had strong moral principles.

When she found the widow Hales (Alice) Thorpe 'entertaining' a soldier named John, she insisted upon making their commitment respectable by marrying them over the broomstick. A birch besom was placed aslant in the doorway of the house. First the young man jumped over it then the girl, but if either touched or knocked it in any way, the marriage was not recognised. In this kind of marriage the woman kept her own home and did not become the property of her husband, any child was legitimate and if the couple decided to divorce within the first year, they simply jumped back over the broomstick again.

The Witch's Tree at Shardlow

In an area called Ridings Hill near Shardlow stands an island of higher ground within the flood plain between the Trent and Mersey Canal and the River Trent. The area

was called Dead Man's Drop as the gibbet had stood there, and 80 yards away was a solitary oak tree. When gravel began to be dug out of the area, rumours started to circulate about the oak being a witch's tree, planted to contain the body of a witch within its roots, and protected by a curse on anyone who removed the tree. Five sturdy trees were torn out, but no-one was brave enough to touch the oak despite the loss of 11,000 tons of gravel.

With the construction of the A50, Tarmac moved in. They questioned the lone tree and soon the Derby telegraph ran the story, but there was another mystery too. A cottage that had once been a communal milking barn was destroyed and 40 yards away in the foundations of a second were found two skeletons with their hands and heads cut off. Who they were, like the identity of the witch in the roots of the tree will never be known.

Gallows Trees

The branches of trees have long since been the site of executions, both just and unjust. Certain trees that grew in a slanting position or with one straight branch that extended out parallel to the ground were used as gallows trees, and often the name lives on in names such as the Gibbet Oak or Hanged Man Tree. If a dog is afraid to approach a tree, it could be because it is one on which a man was once hanged.

Old Ned was a carrier who lived in the vicinity of Stoke Hall, but he was a very unhappy soul. On many occasions he had tried to hang himself, but for some mysterious reason, the chosen branch always broke under his weight. Eventually he managed to take his own life by throwing a rope over a beam in the old barn by the side of the Derwent. It is here that his ghost is still seen wandering around with a rope, tearing off the branches from the trees and finally disappearing over the crumbling walls into the ruined barn.

The Anti-Witch Tree – the Rowan

The Americans call it Rowan and we call it Mountain Ash. It is one of the most familiar trees in the British Isles as it grows quite prolifically, giving certain Derbyshire places like Ashover, Ashbourne and Ashford–in-the-Water their prefix. It can be found in many graveyards where it was planted to protect the deceased from the various nefarious night creatures that haunted the graveyards and was even planted on graves to keep the deceased from haunting.

It has also acquired numerous English Folk names like Quickbane, Rune tree, Thor's helper, Whispering tree, Wicken tree, Wiggin, Witch wood, and Witchbane. The mythological association with these names and witchcraft is very evident so would you be surprised to find that it was credited with curative properties. To take away a 'fluxe' it was recommended to walk round the tree three times while saying – *whiken tree, whiken tree take away this fluxe from me.*

The wood which is very dense is used for carving and turning such things as tool handles and walking sticks. It was also made into Druids staffs, dowsing rods, rune staves, divining rods and magic wands.

The protective property of Mountain Ash was acknowledged way before 1597 when James I included it in his book of Daemonologie. Known as the anti-witch tree, in an

age when superstition and credulity was rife, many people took branches of Mountain Ash into their homes for protection as it was believed to be especially potent against witches and their magic, and act as a counter charm against sorcery. Housewives used it as broom handles, the fire was poked with a length and carters made whips from the mountain ash tree to protect them and their horse on their journeys. A piece of rowan wound with red thread could be sewn into a garment to provide personal protection or tied round a farm animal. and attached to cattle sheds to protect the cattle from harm. It would be kept in houses to guard against lightning, and carried on sea-going vessels in the belief that it would guard against storms.

The old Derbyshire lead miners had great faith in the protective power of the Mountain Ash and took branches down the mines. If a piece of machinery wasn't working, it was quite normal to cover it in a protective layer of branches from the Rowan tree or Mountain Ash. When a pumping engine at a mine in Calver refused to work, it was covered in the believed that the machinery would then be protected from witches who had used a spell to stop it working efficiently.

Magical Cures and Votive Trees
People had faith that trees could remedy all ills. A laurel wreath hung on the door was believed to prevent disease entering the house and wearing laurel leaves would supposedly avert the plague.

The positive and negative attributes of elder, the tree on which Judas hanged himself have been reported for centuries. It was widely reported as being useful in the prevention and cure of ailments as diverse as epilepsy and saddle sores, and was given to the bewitched to break the spell and restore them to health. On the other hand, the wood was treated with suspicion, such that it would never be made into cradles.

Notches were cut in the bark of birch and ash and a small lock of human hair placed in the notch to cure whooping cough. Pushing a pin into an ash tree cured warts, and a nail hammered into an oak tree cured toothache.

To cure a wasting limb, it was recommended to bore a hole in the willow tree and fill it with nail parings and hair from the limb. A hollow willow tree was also supposed to cure argue, if the sufferer breathed three times into the cavity then stopped it up.

These cures might appear to us to be totally bizarre and useless yet many people still believe that trees have special powers of healing. Hawthorns or trees that are associated with protection from the evil eye are still used as votive or rag trees They were seen and reported as early as the fourth century and were hung with strips of cloth, rags, handkerchiefs, scarves and other items of clothing as well as garlands of flowers, which represent pleas for healing and improvement in fortune. There is a belief that the tree itself bears the weight of the illnesses people are trying to rid themselves of, and by the time the offering rots off the branch, the request will apparently be granted. One such specimen can be found on Stanton Moor.

Dowsing or Divining
The association of trees with wisdom and knowledge is recognised in the age old tradition of divining. A forked branch from a tree used as a divining rod is mysteriously

Votive trees are hung with requests
for healing

able to summon up the secrets of the earth, including predicting the presence of hidden
water or buried treasure. Although most people now only associated divining with
discovering the presence of water, the original uses of the divining rods were many,
including driving out devils. A divining rod is quite capable of 'sensing' many other
things, including ghosts.

According to ancient belief, for a diving rod to have maximum potency, it should be
cut between sunset and sunrise ideally on a holy day or new moon. Some say it should
be cut on the first new moon after the winter solstice. If cut in the morning, it should
be the branch on which the sun first shines. Look for a supple undamaged branch with
a strong joint at the Y. If it is brittle it will break easily, so you need a branch that is
young but not green. Hazel is the most popular, but beech, apple, birch, willow and
privet can be used. It should be around 1cm in diameter and as even as possible. In
other words as you hold the two stems, the single stem must point straight ahead not to
the left or right, rather like a catapult. Use secateurs or a knife to cut it from the branch
so that the single stem is approximately 15cm long and each of the two branches are at
least 20cm. Trim, but leave the bark on.

To use your dowsing rod, grasp the forks firmly between the thumb and two first
fingers of each hand. The rod and your forearms should be in the same horizontal
plane, and your elbows should be well tucked in. Move your fists apart until the
twig is tense, balanced and pointing straight ahead, then walk slowly forward. On

Point the dowsing rod straight forward and it will flick up when it locates water, treasure or ghosts

encountering water – or treasure – or ghosts – the joint of the branch will flick up or down or revolve completely. We look at this in more detail in 'psychokenesis using dowsing rods' in Chapter 5.

The Magic Wand

Tree branches are also fashioned into wands which by tradition are agents of intense psychic energy usually associated with witchcraft. The cutting and shaping of a magic wand was usually carried out in great secrecy, with prayers offered to give the rod power and authority. Hazel was a favourite wood, and a branch would be cut at sunrise to endow it with maximum solar energy.

The effectiveness of a wand and its specific power depends upon the wood used. Traditional attributes include –

Ash – reverence
Hickory – endurance and firmness of belief
Maple – kinship, energy, healing and enthusiasm
Oak – increased awareness and heightened consciousness
Popular – protection, resolution
Beech – achievement of goals
Pine – new beginnings
Willow – deters evil

To communicate with Satan, witches would choose cypress, the tree of death.
Witches also made wands of elder to locate buried treasure, to test a girl's virginity and to identify murderers, thieves and other criminals.

Spook Lights, Aerial Phantoms
UFOs, Phantom Planes, Extraterrestrial Visitations and Things that Fall from the Sky

Just as earth energy has always fascinated and mystified man, the sky also held inexplicable mysteries. To early man, a rainbow was an unexplained phenomena. He would have viewed a rainbow, a mysterious cloud formation, ball lightening or a fireball meteor as awesome, mysterious signs from the gods. He would have read and interpreted the shapes formed by clouds, listened to the sound of the wind, marvelled at the ferocity of storms, and the colours of a rainbow.

Sky watching comes under the general heading of aeromancy which is subdivided into Austromancy – divination by the study of winds; Ceraunoscopy – divination by thunder and lightening; Chaomancy – divination from aerial visions and Meteormancy – divination from meteors and shooting stars. Now people are more familiar with the term Ufology to describe an unidentified flying objects (UFO) which could be any aerial object or event unexplainable in terms of known phenomena.

Approximately 90% of all reported nocturnal UFO sightings are of lights. Phantom lights are a phenomenon long associated with hauntings all over the world, but they appear more regularly in certain well defined areas and one of those is the Peak District of Derbyshire. It's called a window area, the concept of which dates back to the 1960s. Window areas are places where the level of extraordinary phenomena is reported just a bit more often than elsewhere and they have long term pedigrees.

A strange glow above a hill in 1600 would be considered a ghost light of demonic origin, in 2000 it would be reported as a UFO. Explanations have changed but the lights remain. The parish records at Chapel-en-le-Frith seem to have recorded Derbyshire's oldest reported incident of a strange, bright light which was seen in the sky between the hours of 9pm and midnight on 30 March 1716. Apparently it was bright enough to read a book by. Nearly 300 years later, people are still reporting similar lights to the mountain rescue team, in the belief that they are distress flares.

The lights vary in size, form, shape, colour and intensity; some are stationary, some mobile and some, known as earth lights hover close to the ground. One theory put forward, is that earth lights are caused by radio active ore, but when these areas have been checked with a Geiger counter there is no evidence of radiation. Another theory

Rainbow over Ogston Reservoir would have been viewed by Early Man as a mysterious sign from the gods

is that they are caused by some kind of reflection but this has also been dismissed because the lights are seen mostly in the darkness. Some are misperceptions – some have far less exotic explanations like the moon rising.

Ghost and Spook Lights

In folklore the lights were often attributed to supernatural or magical phenomena such as ghostly spirits so its not surprising to find them referred to as ghost or spook lights. The rapid playful movement of the lights suggested that they possessed some kind of low order of intelligence like luminous insects or elementals, and in some areas, they were known as Spunkies a dialect word for spark. These ghost lights have a variety of names locally. There's will-o'-the-wisp, jack-lantern, St Elmo's fire or Ignis Fatuus from Medieval Latin, literally meaning foolish fire. They move up and down in crazy patterns far too quickly for them to be the lights of a car or motorbike and some people believe they even relate to people. As this is an old lead mining area, the more superstitious inhabitants believe that these are the lights from the helmets of the long-dead miners still searching for lead.

Lights Over Marshland

Our ancestors believed that mischievous fairies or evil spirits used lights to lead mesmerised travellers from their safe paths to bogs, mires and pools where they would

Strange lights in the sky are not new

be swallowed up. It's the stuff of fairytales, but what better theories do we have? Over marshland these sightings can be readily explained as marsh gases, the rotting vegetation and animal matter that produces a chemical soup which bubbles up through the bog letting off unctuous, condensed vapours. When ignited this could produce wispy flames, but what ignites these gases? Also the vapours would be more likely to burn on the surface rather than float upwards and hover as if caught and carried by air currents.

Lights in the Graveyard
Churchyards, where the stage is set for the last act of human drama, are the natural theatre for ghosts. Some even have what have become known as cemetery lights, corpse candles or spook lights, that hover over graves after dark as bluish balls of light. In the olden days these flickering lights were believed to be caused by the soul, which detaches itself from the physical body at death, and can occasionally be seen as a glowing light. The size of the light indicates the age of the person; the larger the light, the older the person. If the colour of the flame is white, it's a woman, if red, a man.

Lights Over Rocks
Spook lights are often seen on mountains and rocky gritstone uplands. They appear around outcrops like Lunter Rocks above the village of Winster and Harborough

Ghostly lights are sometimes seen in graveyards

Rocks near Brassington. They hover over old standing stones like Arbor Low and Stanton Moor and although these strange elusive lights seem to prefer the gritstone areas of the northern Peak District, there have also been reports around Dovedale and the Manifold Valley.

One explanation is that the local millstone rocks are rich in quartz crystals which vibrate when under pressure, so these earthlights could be the natural light emissions squeezed out of the rocks under geographical stress to create an atmospheric glow. Quartz crystals are used in watches and cigarette lighters where the pressure button crushes a crystal, causing a vibration and generating a tiny surge of electrical energy which provides the spark that can ignite flammable gases. Could a mass of quartz bearing rock under strain produce an electrical signal that causes a chain reaction and triggers glowing spook lights that can be seen in the surrounding atmosphere? Some regional lights are seen so regularly that they have been given individual names like Peggy wi' th' lantern, a strange yellow light which entices foolish followers to their deaths high on the summit of Lantern Pike.

The Carsington Light

There's a story that dates back almost two centuries, and is said to explain a certain mysterious light that hovers over the hills around Carsington. The lady of the house sent her maidservant to collect water from the well, but the girl took so long that when she returned, the woman thrashed her unmercifully. The poor girl died from her injuries and although the woman was brought to trial, she called upon an old law that declared that *'should the murderer touch his victim, the wounds would bleed anew'*. This was known as Ordeal of Touch, and because the wounds did not suddenly spurt blood when the woman touched them, she was considered innocent and set free.

She may have escaped the gallows, but her ordeal was about to begin because from then on, every night she was visited by the ghost of the deceased maid who always stayed until cock-crow. These visits so terrified the woman that she paid people to stay with her overnight and often, fortified by alcohol, these individuals caused such a disturbance, fights broke out amongst the inebriated visitors.

Eventually a gathering of clergy were summoned to exorcise the ghost of the poor maid but it would not go quietly. The spirit was finally put to rest on the hills where, from then on it appeared as a dim light. Locals recognised it as the phantom and coachmen always made a point of pointing it out to their passengers and acquainting them with the story of the melancholic maid.

The Longendale Lights

Known locally as the Devil's Bonfire, the Longendale Lights have been haunting the gritstone crags on the north face of Bleaklow for so long they have become part of the folklore of the region. They are also linked to the phantom legions of Roman soldiers who tramp across the darkened moors on the night of the first full moon in the Spring. The ghostly glow is said to be flames from the torches carried by the auxiliaries marching along the route of a Roman road linking the fort at Glossop with the Hope Valley.

The lights seem to be concentrated around the hairpin bend known as the Devil's Elbow on the back road from Glossop to the short steep-sided valley known as Shining Clough at the eastern end of the valley, or around the strange isolated mound in the north-west of Bleaklow summit known as Torside Castle, a purely natural, probably glacial feature.

The string of moving lights have been mistaken for hiker's torches high on the mountainside, searchlight beams, distress flares, ball lighting, or rare electrical phenomena. Walkers who become disorientated as darkness falls have seen the lights and believing them to be a distant village have followed them, only to find the light continued to move away from them.

On 22 February 1993 four people were driving near Devil's Elbow around 8.40 p.m. They all reported seeing a strange white glow in the north east towards Mossley. It should be pointed out that there is a pulsing light in the area, the beacon of the Holme Moss TV transmitter mast. When seen through mist this can be quite eerie, but in most instances this is ruled out completely.

The lights are said to be the flames from the torches being carried by the Roman soldiers

On 28 January 1989, the Charlesworth family of New Mills reported a midnight sighting that lasted about three minutes. Three of them watched and debated. They described the light as unmoving and lighting up the valley like a floodlight. It had rays of light coming out, then all of a sudden it was not there any more. At first they thought it might be a car headlight but when they later compared this with a car on the hillside it was nothing like it. The alien light was much brighter, and about half the size of the full moon.

In April 1983, two doctors on a walking holiday spotted a silver-blue ball of light. It was 1.00pm on a perfectly clear day allowing them to witness the object as it drifted across Sykes Moor before rising suddenly and rapidly into the clouds.

It was a warm summer evening, the sun was setting when Pam saw three bright lights in the sky over her Derbyshire home. 'My first thought was stars,' she said, ' but no stars made that kind of formation. Then one of them broke away and made a zig-zag pattern across the sky, then they all shot off at great speed.'

Rita spoke of her experience over the Hope valley. 'It was a warm summer evening and the sky was cloudless but a few stars were out already, then suddenly streaming across

the sky was a bright white ball of light. At first I thought it was a shooting star but it maintained a straight path, lower than any aircraft, and had no flashing lights.'

The strange blue and green lights that appeared above Matlock during a heavy snow storm in 2007 are still something of a meteorological mystery. The phenomenon which also caused house lights to flicker was seen at around 7.15 pm and witness Rob Brook of Tansley said it was accompanied by a sound like something out of close encounters. A spokesman for the Met Office initially suggested it could have been lightning refracted through the snow, but following more detailed analysis, a report prepared by the met office for the *Matlock Mercury* said '*A quick look at the lightning location data on February 9th in the Matlock area, shows that our system detected no lightning at the times of interest, or indeed outside of these times. The system has a variable detection efficiency and does not guarantee to sense all lightning activity that occurs. It is also optimised to detect cloud to ground lightning, which is usually the more powerful lightning, rather than inter or intra cloud lightning. However what was seen in this snow event may have more to do with electrostatic charging in the snow. Sandstorms and blizzards are known to cause such charging.*'

Similar reports abound throughout Derbyshire, but we are no nearer reaching a satisfactory answer as to what these lights are. Some form of glowing nocturnal insect like a fire-fly is ruled out because even if they were really much closer than they seem, the reported light anomalies are far too big for fireflies.

Fireball meteors are another possibility although such sightings are rare and unpredictable. Basically a fireball is caused by the entry into the earth's atmosphere of a larger than usual object defined as a meteor as bright as the planet Venus in the night sky. Observers have described them as having a long, glowing tail and a roaring sound that accompanies their flight. In earlier times fireballs were interpreted as falling stars and evil omens which expressed the anger of the gods; in more recent years they have generated UFO reports.

In recently years there have been hundreds of sightings by balanced individuals who have nothing to gain by inventing, elaborating or embroidering what they fundamentally believe they have seen or experienced, yet most UFO sightings can be explained by atmospheric conditions, normal aircraft activity and hot air balloons. Once they are explained they become IFO identified flying objects

The most recently reported lights in the sky are orange lights.

Steve lives on a hillside above the town of New Mills with views down over the valley towards Buxton. On 4 March 2010 at 1.15 a.m, he saw three orange lights in the sky in an exact straight line moving very slowly and deliberately in a south easterly direction. Mick Ballard of South Normanton saw a bright orange light in the sky on 3 May 2010. It was so bright he thought it was a helicopter on fire. On 6 May 2010 Mark was driving a mini bus and had just reached the junction of the A619 at Barlborough when he noticed a glowing orange light about 1,500 ft above the ground. On 22 May at Chellaston, people watched a strange ball of red/orange light which

An orange hot air balloon

seemed to come out of nowhere. At Mickleover on 22 May, a couple reported seeing an orange object moving silently across the sky, and on 29 May 2010 Terry Allen of Kilburn saw a single orange light travelling in a straight line from west to east just below the cloud level.

Dale saw lights in the sky that glowed orange then red and moved in a peculiar way. They vanished then reappeared one at a time. They were moving in a slow and definite pattern and every so often would stop as if waiting for the others to catch up. They appeared spherical and made no obvious noise. The lights were accompanied by five or six smaller blue lights, then a larger silver-coloured light joined the formation and about 30 seconds later the larger silver object abruptly shot off in an easterly direction and the others followed.

Roger said – 'I saw lights in the sky travelling north to south in a triangular formation There were two orange lights and the lead one was bright silver. They couldn't have been part of the same object as they were too far apart from each other.'

All these reports prompted a response from Councillor Juliette Blake, Heanor and Ambergate, Amber Valley Borough Council.

'Sorry to give such a boring and practical explanation, but these orange lights are a regular sight around this area. They are mostly Chinese lanterns – referred to a 'Khoon Fay', sold in Ripley at £3 each and used by the Chinese to banish evil spirits. They work like mini hot-air balloons, are completely silent and burn out within ten

Setting off colourful sky lanterns that are often mistaken for UFOs

minutes. The floating orbs appear to just float and then look like they are following each other as they are pushed along by the wind, so don't think the Martians have landed in Derbyshire yet.'

Chinese sky lanterns are a common cause of false UFO sightings. They are made like a bag, of fine coloured paper which is inflated with warm air from a built in fuel source which makes them glow as they float. People who are not familiar with them are stunned, believing they are witnessing UFOs moving across the sky. No doubt as these lanterns get more well known the reports will diminish. They are immensely popular and already people have coined the acronym OBOL – 'orange ball of light'.

Did anyone see the UFOs?

Madam,
Has anyone reported the strange moving objects/lights in the sky over Matlock on Saturday evening around 9pm?

There is most likely an explanation for the objects/lights however they certainly presented an unusual sight. I was travelling back to Wirksworth along the A6 from the Darley Dale direction when I saw the lights. I pulled over and entered the car park just past the railway bridge so that I could observe them.

At first I thought they could be those Chinese lanterns, however given the speed they were travelling this could not be the case.

The objects appeared to have lights permanently switched on yet one of them switched off its light as it passed over the area where I was parked and then it was just visible against the fading daylight. The shape was most unusual, a sort of mix between triangular and circular.

They also appeared to be moving quite quickly, came close together, then separated and then came close together again.

Then I heard one of them emitting with what I thought sounded similar to a normal jet engine. I then assumed they could be military aircraft perhaps returning from an air show somewhere?

A very interesting experience and sighting nonetheless.

Any explanation would be welcomed.

by email phil_bramhall@tiscali.co.uk

'UFOs' were only lanterns

Madam,
We had a perfect view from Lea of the "UFOs" on Saturday evening as they drifted silently from Cromford direction over Riber.

Sorry to disappoint, but having looked through binoculars they were unequivocally... Chinese lanterns.

Kevin Bradbury
Matlock

Letters sent to the *Matlock Mercury* about a sighting on 21 August 2010

Omar Fowler, group leader of Derbyshire Phenomenon Research Association said that the decision made by the Ministry of Defence to release reports of UFO sightings shows there have been more than 11,000 UFO sightings in Britain in the past thirty years and interest in spotting them is growing. Mr Fowler said that there are more sightings of UFOs in Derbyshire than many parts of the country, and unusually high numbers of unidentified flying objects (UFOs) have been spotted in the Derbyshire sky this last few years. Some are reported in the paper like this in the letters page of the *Matlock Mercury* 26 August 2010 which got a response the following week.

Approximately 90% of all reported nocturnal UFO sightings are lights in the sky and many are eventually identified as aircraft lights, laser search lights, meteors, stars, planets and satellites. Most ufologists agree that only between one and five percent of reported sightings should really be considered to be UFOs. After investigation, the remainder are generally found to be Identified Flying Objects or IFOs.

But don't be disheartened! If you see any lights in the sky ask yourself – Does the light move in a peculiar way? Does it hover, then shoot off at great speed? Does it make any obvious noise? Does the light seem surreal? Is it flying lower than an aircraft flight path? Could it be a plane or helicopter, a hot air balloon, a sky lantern, the moon's reflection, a bright star, a shooting star? Is there anything more substantial? Take a photograph or better still, use your camcorder to record the event.

The Bonsal UFO

A chance filming on 5 October 2000 with a camcorder she had received only days earlier could have made Sharon Rowlands £20,000 better off. Not bad for a six and a half minute tape reportedly showing an unidentified flying object over her Bonsal home. Forty four year old Sharon lives with husband Hayden at Slaley on the outskirts of Bonsal, and the footage prompted an unprecedented amount of reputed UFO activities with villagers now regularly reporting sightings and the local pub offering UFO walks.

A Meteorological Officer spokesman said there was no freak weather conditions on 5 October which could have caused the circular shape in the sky when the UFO was filmed. UFO enthusiast Omar Fowler founder of the Derby based Phenomenon Research Association has been tracking UFO activity since the 1970s. He believes that Bonsal is one of the foremost UFO hotbeds and after viewing Sharon Rowland's tape said he was amazed at what he saw. 'I consider it to be one of the most important sightings of recent years, comparing very well with a recent clip from Mexico. It typifies activity in Bonsal. The Rowland's tape will shock a lot of people because the image is the same as the one taken by NASA's own cameras showing what appeared to be a UFO hovering in space.'

The Bonsall UFO

20,000 UFO photographs have been studied over the years

The American space agency NASA is believed to be interested in the Rowland's footage because of its marked resemblance to a photograph taken by astronaut and mission specialist Claude Nicoltier during the 1996 STS-75 mission.

California based Kiviat Productions obviously agreed because they reputedly snapped up the film and are negotiating with TV networks across the world to show the tape as part of the *'Could It Be True?'* series. Kiviat executive producer Robert Kiviat found Mrs Rowlands film footage while scouring the internet and declared that it is one of the top five pieces of video footage of UFOs ever taken.

The first known photograph of a UFO was taken by an astronomer in 1882 in Mexico, and since then an estimated 20,000 cases of apparent UFO photographs have been studied. There are many impressive examples of misperception with mundane subjects such as aircraft, flying birds, hang gliders, hot air balloons and sky lanterns. When planets like Venus are particularly bright, and suddenly appearing and disappearing behind wind blown clouds, this gives the illusion of a UFO. Some sources are unique to the camera lens, like sunlight reflecting inside the lens system. The fact that many UFO sightings are taken at night greatly increases the problem of evaluating the cause and distance. Zoom lenses and automatic focusing struggles to identify the object clearly so the poor resolution makes them of limited value.

Aerial Phantoms

Recordings of unexplained objects in the sky exist in the archives of many major civilisations dating back more than 2,500 years. Frequently such data is described in terms that are familiar to the local populations and they became known as aerial phantoms. Some cultures believe that they are a warning sign or omen, while others consider them to have a symbolic or prophetic meaning. A very ancient, archetypal aerial phantom in European mythology is the wild hunt. It could have Viking origin, as one of their myths was the legend of the Hounds of Odin, also known as the Hounds of the Underworld or Otherworld – the regions below the earth's surface – the abode of the dead. The god Odin was said to ride across the sky on a phantom horse, Slepinir, followed by a pack of spectral hounds chasing lost souls.

The aerial hunt could also stem from ancient Greek mythology and the goddess Diana who on a white horse and accompanied by her pack of spectral hounds rode across the moonlit sky searching for lost souls. Whichever version you prefer, the story is widespread.

Bretton Clough between Eyam and Hathersage is a secluded wooded valley that has an eerie reputation in the neighbouring villages. The name is of ancient Celtic origin meaning 'the farm of the Britons', and it's said to be haunted by a phantom huntsman and hounds. In *The Ghost Book*, A. A. McGregor refers to this when he writes that among the people who claim to have seen the phantom hunt were the Revd Brooksbank, a former vicar of Hathersage church, and the Hodgkinson sisters, owners of Moorseats Hall, Hathersage.

Dr Mary Andrews of Shatton, the author of *Long Ago in Peakland*, also reports that during the 1930s she and a companion were walking through Bretton Clough when they heard the sound of a hunting horn. They looked around expecting to see a hunt approaching but there was nothing and they could find no explanation for the sound of the horn. It was some years later that she heard for the first time about the phantom hunt that was often heard in the valley.

Throughout England, there are tales of spectral hounds that howl as they glide through the sky on wild, stormy nights. Often they are heard rather than seen and the sound of their ghostly cries are said to be a sign of impending death or doom. In North Derbyshire and the Peak District they are known as The Rach Hounds or Gabriel Hounds. A rational explanation would be that the sound is made by geese but people who have heard them are unconvinced. The prophetic ability of these hounds was widely accepted, and at the outbreak of the plague in Eyam in 1665, many of the people were sure that they had previously heard the Gabriel Hounds.

Accounts of aerial phantoms enjoyed a particular vogue in the sixteenth and seventeenth centuries, but as scientific knowledge of the universe has expanded these things have been re-interpreted as naturally occurring phenomena such as meteors or lightening. This led to fewer accounts of aerial phantoms yet a new era was dawning; aerial phantoms had evolved and been replaced by unidentified flying objects.

Ufology

Sightings of what we now call unidentified flying objects (UFOs) have been described using a wide range of different terms because UFO sightings are not a modern phenomena.

Spectral hounds are heard but seldom seen at Bretton Clough

In Victorian times most reported cases were described as resembling dirigibles or airships. The most popular theory was that the craft were the product of mysterious inventors who would soon reveal their amazing technology, yet it wasn't until 1912 that the first German built Zeppelins were successfully flown in the manner described by many of the early witnesses. In the years leading up to the first world war, a new burst of airship sightings were the subject of parliamentary debate, fuelling fears of an imminent German invasion. To prevent mass panic, a newspaper article dated 2 February 1913 reported that the cause could be pinpointed to the fact that Venus was very bright at that point and could be seen intermittently appearing behind wind-blown clouds.

In 1946, UFOs were Ghost Rockets and the first sighting reported to the US military during the summer of 1947 were called flying discs. But none of these captured the public imagination like the term flying saucer and that was born out of a misunderstanding. The day after an alleged unidentified flying object (UFO) sighting by Kenneth Arnold in Mount Rainier, USA, he gave an interview describing the objects he had seen as being crescent shaped and 'flying like a saucer would if you skipped it across water'. The reporter misinterpreted this and stated that the craft was saucer like, and within hours headline writers were calling them 'flying saucers'. It became so widely accepted that it still remains in widespread use even in the twenty-first century.

Flying Triangles

Since the 1970s, one of the most reported types of UFOs is the flying triangle which according to witnesses resembled a Vulcan bomber, the huge triangular plane then still in use by the RAF. UFO researchers suspect that it might be a new kind of terrestrial aircraft or spy plane.

A family holding a barbeque in Locko Road, Spondon in July 2008 saw an orange triangle floating across the sky at about 10,000ft. Twenty two year old John Jordan said – 'the triangle looked like a burning plane but was silent, then a moment later, a similar object took the same flight path and disappeared. We ruled out the idea that they could have been planes or helicopters because there was no noise. We reported it to the police who took a record but we have heard nothing since.'

'We have had reports from people living in the flight path of East Midland Airport, who spotted jumbo shaped objects with smaller objects following them.' said Omar Fowler, group leader of Derby's Phenomenon Research Association. 'These people are very knowledgeable about planes and are not likely to be confused into thinking they are normal aircraft operating.'

According to Omar Fowler there was a previous spate of flying triangles spotted in Derbyshire between December 1994 and May 1995 when fifty two were seen. Mr Fowler of Sinfin, a former aero-engine fitter for the test pilot school at Farnborough, said, 'I have spoken to someone working on a project to do with stealth aircraft, who said they were not the kind of planes he worked on – certainly they are not British craft.'

Recent reports in Derbyshire are of a blue, shimmering craft flying at 10,000ft over Sheldon Lock on 22 July 2008. Bright blue lights zig-zagging through the sky at high speed have been seen over Rainworth, Mansfield on 19 April 2010. There are reports of a large silver, oval shaped object hovering silently over Bolsover at 20.05 on 30 April 2010. At Wirksworth on 18 April 2010, four friends watched what they originally thought were two stars until they shot across the sky, one following the other. On 4 May in Bradley near Ashbourne people saw a very bright whitish light similar in intensity to the front headlights of a plane, about one mile due south of them, travelling east.

THE PHANTOM PLANES OF THE PEAK

The manifestation of ghost aeroplanes either seen or heard have emerged sporadically since the 1930s. Some have been considered as an aspect of wide UFO phenomena, but in other cases the phantom is identified as a specific aircraft which is known to have crashed in that area. One of the most spectacular hauntings is the phantom plane that flies over Bleaklow Hill.

It was 18 May 1945, just ten days after the Second World War had ended and the men of the Royal Canadian Air Force were just counting the days to 20 June 20 when they were due to fly back home. A big send off was planned by the local people and their British colleagues but counting the days was a boring occupation for men used

There are numerous sightings of soundless grey aircraft flying silently over the Derbyshire hills near Ladybower reservoir

to action. To keep the men occupied, cross country flights and routine exercises were undertaken by all the crews and on this day, the six man crew of Lancaster KB993, part of the Royal Canadian Air Force 'Goose' Squadron, took off from RAF Linton On Ouse, for what was to be their final flight.

This experienced crew consisted of Flying Officer Anthony Arthur Clifford, Bomb Aimer 'Scratch' Fehrman, Wireless Operator 'Blood and Guts' Cameron, Air Gunners 'Hairless Joe' Halvorson and 'Rabbit' Hellerson, and Flight Engineer 'Gassless' Mc Iver. They had been formed in 1941, just one of many RCAF squadrons which served at Allied bases overseas. Ironically on this fateful voyage, their navigator 'Gee Sam' had not accompanied them as they had only been cleared for local flying.

They were taking a circular tour of the region, passing over South Yorkshire and the Derbyshire border when in the middle of Derbyshire's mist-shrouded Pennines, the plane suddenly plunged straight into James Thorn, GR077949 at full speed and burst into a ball of flame. Five of the crew died instantly, the rear gunner managed to crawl clear of the wreckage but died of his burns.

Six men who had braved the war over Germany had been tragically killed in routine training, but this tragedy seemed to mark the beginning of a rather disturbing trend. Just two months later and 50 yards away from the same site, a USAF Dakota crashed in similar circumstances killing its seven man crew, and the tragic history continues with 50 planes in as many years coming down over this stretch of the moors.

But it is not just the mystery of the multiple crashes that perplex local people. Clairvoyants and psychics have been contacted by dead airmen, and a local farmer who rescued some of the wreckage to use as spare parts watched the barn where it was stored, shake uncontrollably. He returned it to the crash site next day and things returned to normal.

There have been numerous sightings of ghostly grey aeroplanes which have been seen flying in eerie silence in action replays. Some people have even reported seeing the planes flying low before plunging down into the peaty bogs of the moorland to disappear without trace. Initially it was believed that the people who witnessed these paranormal flights were just recalling something they had previously viewed, until it was realised that most of the people who reported these replays of phantom planes have never seen them in reality. Other theories have been considered and found lacking too.

The ghostly figures of the men that perished have also been seen by hikers, campers and motorists. Phantom figures wearing flying jackets have been spotted hovering near their shattered flight decks. In fact sightings of ghostly planes and phantom airmen are so numerous that they have become woven into the rich tapestry of paranormal events that are rife in the area.

In April 1994, retired postman Tony Ingle was walking his dog Ben near the hill which overlooks the crash site of the Lancaster and Dakota when suddenly the sunshine overhead was blocked out by a propeller driven plane which Tony later identified as a Dakota. He said he could see the propellers going round yet there was no sound, just a deadly silence. He watched the plane banking as it tried to turn, then it disappeared over the crest of the hill. Tony and Ben sprinted to the top of the hill and gazed down, convinced that the plane had come down, but the field was empty. Tony, who until then was a firm disbeliever in such things as ghosts, has regularly returned to the site to try to fathom out just how such a thing could have happened, but Ben refuses to go anywhere near it. On one occasion when Tony tried to force him, Ben slipped his collar and ran.

For a long time, people have been seeing mystery aircraft plunging down on these moors and there have been fruitless searches for them. Sometimes there are numerous witnesses whose testimonies tally. Some of these witnesses are no-nonsense farmers who pooh-pooh the very idea of ghost stories yet admit that these Derbyshire hills have a means of tapping into some kind of memory field.

EXTRATERRESTRIAL VISITATIONS

Mr Fowler said the Derby Phenomenon Research Association would normally receive reports of about twenty-five sightings of UFOs a year, but now it could be over eight per month. Over the last fifty years not only have more people been taking an interest in UFOs, people have began questioning the reason behind them. Instead of being regarded as supernatural signs or natural wonders, these modern UFOs started to be attributed to the actions of visitors from outer space. Could there be pockets of bizarre

activity scattered around the globe that act almost like portals for another reality allowing all sorts of weird phenomena and alien entities to enter our world? After all, man had conquered the heavens, sending rockets to the moon and beyond, so why shouldn't there be aliens who had found the means to visit earth?

When modern UFOs started to be attributed to the actions of visitors from outer space, people began to ask what would happen if they landed? Suddenly Extraterrestrial visitations became a big issue fuelled by the fact that some individuals claimed to have met with aliens and been abducted.

On 20 December 1988 at 7.40 a.m. a man was riding his moped from Ellaston to work at Ashbourne when he spotted a pyramid of light in the sky. A weird isolation effect occurred. He experienced a peculiar sense of calm, then suddenly the pyramid of light had gone but the man was feeling unwell and his motorbike was malfunctioning. He had a pounding headache, sore eyes, dizziness and tingling sensation like pins and needles, all classic witness symptoms widely reported after experiencing such energy encounters. These gradually subsided but what he couldn't explain was the time lapse. He had lost a considerable number of minutes.

Even more bizarre cases began to emerge. Most scientists accept the fact that there are dimensions other than the three that we inhabit, but if these dimensions do exist, who or what inhabits them? Some theories maintain that holdings beyond our own are real and run alongside ours. For centuries psychics and mystics have claimed that these other dimensions are inhabited by otherworldly beings so are we being visited by them?

So the mythology grew, fuelled by sensationalist books, films and TV series. The media soon realised that the more extraordinary the suggested interpretation of such air borne oddities, the more people would be interested. There were stories by those who believe in world infiltration and domination by an alien species, and people claiming to be able to communicate telepathically with other planets. The Government's silence implied that they were keeping, guilty secrets which helped to fuel all kinds of incredible stories.

On 15 July 1995 at a house in the Calder Valley, four people having a barbeque found themselves surrounded by a grey mist, lost all sense of space and time and 'came to' some time later with the environment around them, inexplicably different. Their recall as one man put it 'like a video tape cut to pieces and re-assembled out of order'. They felt physically sick and also 'out of sync' with reality for a time. It is as if the person is taken on a journey through multiple universes, causing them to feel 'out of phase' until their body re-adjusts, leading to physical symptoms which range from burns to nausea, giddiness and loss of body control.

During the latter years of the twentieth century, the Freedom of Information Act resulted in the release of documents describing UFO investigations. The files indicate that most sightings can be explained, but a few hundred cases per year remain puzzling. However, after dismissing the mundane, there is no physical evidence that the remainder involve any exotic alien technology. After all, no visiting aliens have so

Drawing of an alien by Andre aged seven

far materialised. It concluded that most sightings were caused by various forms of unidentified natural atmospheric phenomena yet still the search for that elusive proof continues.

Researchers continue to investigate sightings but most branches of science will not take the subject seriously until a real alien or material of a definite extraterrestrial origin can be produced and examined. It's considered a pseudoscience because of the lack of scientific method.

It's also interesting to note that of the thousands of photographs taken of UFOs, none feature structured crafts or landed crafts or their alien occupants, despite ufology being dominated by an obsession with the Extraterrestrial Hypothesis.

THINGS THAT FALL FROM THE SKY

There's something romantic about the notion of a shooting star, and it's customary to make a wish if you're fortunate enough to see one. Early man considered them to be the action of the gods, so it's not surprising to find that they have long been the subject of superstitious beliefs. Children were told that a baby boy was born every time a shooting star fell, a story no doubt linked with the Christian nativity story. In some cases, the star is said to be the new soul of the baby itself. In direct opposition, a more widespread superstition holds that a shooting star bodes great ill-luck or death, or the shooting star is the soul of someone who has recently died.

Manna fell from heaven

As the name implies, shooting stars are actually meteors from outer space, as bright as the planet Venus in the night sky. They burn up as they enter the earth's atmosphere, which gives them the additional name of fireball. As they shoot across the sky and plummet to earth, in their wake is a long, glowing tail, and observers have occasionally reported hearing a roaring sound to accompany their flight.

Any part of it that reaches the earth's surface whether it's a lump of stone or metal is known as a meteorite from the Greek word *meteora*, meaning 'things on high'.

The idea that stone and metal could fall from the sky was considered nonsense until the first years of the nineteenth century when it was established that there were rocks drifting through space, and that the composition of most meteorites found on the ground were similar. This theory was cemented when French scientist Jean-Baptiste Biot witnessed a fall and discovered the still hot rock lying on the ground.

Shooting stars are both rare and unpredictable, and meteorite falls still attract much attention. They give scientists clues as to the nature and history of our solar system, and the media gets a good story particularly if a meteorite hits a car, house or person.

Having established a cause for the stones and bits of metal that land on earth from time to time, it's more difficult to explain the coins, fruit, nuts, ice and amphibians have been reported as crashing down to earth, although weird objects falling from the sky are not new. The fall of manna in the Bible is backed by a number of historically verified stories of similar falls of organic goo.

Miscellaneous objects have been falling from the sky long before the first aeroplane was invented

Sand occasionally rains over parts of Britain and when analysed it is found to have come all the way from the Sahara desert. It has been sucked up by an atmospheric vortex and then, after drifting across Europe, dropped 2,000 miles away. The writings of journalist Charles Fort who collected such oddities from the late nineteenth and early twentieth centuries are full of falling things yet we still haven't found a convincing theory to explain such phenomena.

Falling fish is a common theme and the usual explanation is that the creatures were sucked up into the air by an atmospheric vortex akin to a whirlwind which creates a small zone of low gravity that sucks up small creatures and carries them aloft a short distance before depositing them to earth.

Fred Swindon, an industrial officer in Sheffield was about to drive to work on the morning of 23 February 1981 when he found a small shoal of recently dropped fish covering his car. There were too many to be dropped by a bird, but no other obvious explanation could be found. The fish were about three inches long but not wet or surrounded by water, and still flapping. One fish was kept alive by dropping it into his windscreen wiper water-bottle. When analysed it was decided that the fish were local, probably from a nearby river. But how had they dropped from the sky in this way? The most commonly accepted explanation is that they fell from an aeroplane, yet similar incidents involving fish, toads, frogs, crabs and worms have been reported long before the first aeroplane was invented.

Also common are falls of ice, sometimes referred to as 'mystery rain', although this is not mundane rain, hail or sleet but dangerously large lumps of ice. One modern day explanation would be waste falling from jet aircraft flying so high that any liquid leaving them must freeze in the atmosphere. However may accounts of ice-falls pre-date the invention of the aircraft, such as the incident on 8 July 1841, when fish and ice fell from the skies in Derby.

Some ice falls are crystal clear others are milky and some contain rock particles. The suggested explanations for this phenomena range from freak weather to a kind of volcanic activity, but how do we explain Angel Hair, the clusters of gossamer-like threads that fall from the sky?

People who have witnessed these fine filaments falling from the sky have compared it to fine string or cobwebs, that can often cover large areas of ground. Different explanations have been put forward, linking such falls to the frozen contrails of jet aircraft, the activities of UFOs, secret military experiments with radar cloaking material or simply the effects of long term air pollution, but no individual explanation has been able to satisfactorily explain such a phenomena. Because the thread is said to disappear very quickly, particularly if touched, this makes collection and analysis problematic.

Disregarding the man-made solutions, it could just be a natural substance, a sort of silky cob-web parachute spun by so called 'ballooning spiders'. After hatching these arachnids disperse themselves by spinning out silken threads until enough is released to catch the prevailing wind which then carries the spider and their silk parachute through the air.

As with all things paranormal, we need to be cautious how we interpret such things, but if we take away the mystery, the inexplicable and the unsolved, the paranormal becomes just the normal.

Ghosts and Spirits
Captured on Camera

If ghosts and apparitions can be seen by the human eye, there would appear to be no reason why they shouldn't be captured on camera, so it's not surprising to find that since the inception of photography around 1860, there have been numerous photographs allegedly showing ghosts or spirits of the dead, and they've always been controversial.

Photographs of phantoms are exceedingly rare and even those claiming to be genuine are regarded with suspicion by sceptics because the camera is an instrument that can be deliberately manipulated to falsify facts. Some people will have us believe that if a ghost remains at the etheric level, it will not be possible to see it or capture its image with electronic devices unless it is able or willing to materialise through ectoplasm, a semi-physical matter that some mediums can produce.

The first reported case of capturing a spirit on a photograph was in 1860, produced by W. Campbell of New Jersey. One day while experimenting, he took a test photograph of an empty chair. There was no one else in the studio, but when the glass photographic plate (pre film days) was processed, it showed the image of a small boy. Campbell had no idea how the image had been captured and was never able to produce anything similar again.

The following year 1861, a Boston jewellery engraver William Mumler took a self portrait and after developing the photographic plate, he noticed what appeared to be the image of a young woman next to him. He claimed it was the image of a cousin who had been dead for twelve years.

When news of this marvel got around, people flocked to Mumler's studio to sit for photographers in the hope of seeing their dead loved ones revealed in a photograph. This was no doubt helped by the expansion of Spiritualism launched in America in 1848 by two young sisters Margaret and Kate Fox who disclosed that they could converse with the spirits of the deceased. The popularity of spiritualism spread globally, often linked with the new technological developments of the age, so it was believed that if the images of the dead could be captured by photography, it was not only a sign of the existence of ghosts, but of survival after death.

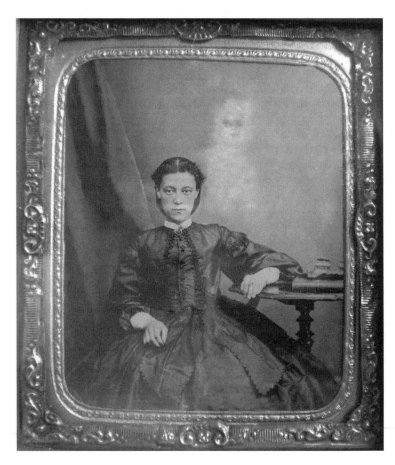

Despite appearing artificial to us, early spirit photography was viewed with awe

Countless bereaved families wanted a spirit photograph as some form of assurance that their lost loved ones were somehow still with them. They grasped at every bit of evidence no matter how flimsy or fraudulent because the will to believe was very strong. Dubious and often deceitful methods were not questioned. Even rather crude methods and humorous results that we would now consider to be so obvious, were viewed with wonder and awe.

Some so called spirits were a piece of white cloth with a cardboard cut out face attached, then a spirit photograph would be produced using the standard photographic technique of double exposure. The 'spirit' would be photographed using a very short exposure, before the same photographic plate was used to photograph the customer. The pre-exposed image would then be just enough to show a faint ghostly image behind the sitter. Double exposure both accidental and fraudulent could account for many of these ghostly images. Many that we would now dismiss as fraudulent were accepted as real, yet it must be understood that photography was in its infancy and everything about it was considered amazing, mysterious and magical. The appearance of a persons image seemed miraculous beyond belief, so for the photograph to contain the image of a ghost seemed just another sensational step.

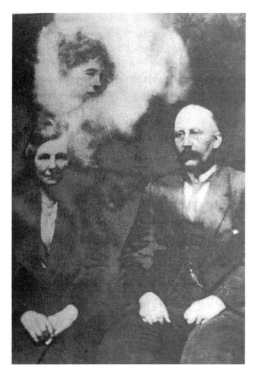

Left: A spirit photograph of a Mr and Mrs Gilbert of the Spiritual Church, Foster Street, Derby, pictured around the time of the First World War, with according to a current member of the church, a returned spirit behind them

Right: Some rather dubious looking spirits

So were these early spirit photographers genuine masters or consummate tricksters? Even after 150 years we are still unable to answer that or explain the ghostly images we call extras that have turned up periodically since.

Thoughtography
In spirit photography it was believed that the sitter could intentionally influence the camera to successfully produce images by using only the power of the mind. This took on an identity of its own in the 1870s, and became known as psychic or mental photography, but the subject provided rather blurred images that were wide open to interpretation, and the subject was not particularly widespread until the mid 1960s. It was then that psychiatrist Jule Eisenbud wrote a book about the ability of an apparently remarkable young man named Ted Serios who was able to project his thoughts onto unexposed polaroid instant film in a polaroid camera. The process required him to maintain sufficient contact with the camera which he did by placing a cardboard tube which he called his gizmo over the camera lens. Eisenbud called the resultant photographs psychographs or thoughtographs and claimed they were produced by pyschokenisis (see Chapter 6). Sceptics suggested that the low-quality, blurred images

were more likely to have been produced by whatever Ted Serios placed in his gizmo rather than images projected from his mind.

Ghosts on Film
Spondon church and the nearby vicarage which is now St Werburgh's House Nursing Home claim to have three ghosts There's an old woman who sits in a rocking chair at an upstairs window gazing out forlornly at the rear garden, a monk and a fair haired lady in a blue dress who in the mid 1970s was photographed by Miss Gwen Nicholls while photographing the interior of St Werburgh's church. The photograph is not of a very good quality and could be explained as a trick of the light.

At the Greyhound pub on Friar Gate, Derby, two students did an all night vigil. There was no one else present, yet they heard footsteps, scratching and knocking sounds within the building. One of the students took a photograph and the picture revealed a misty substance in which appeared to be seated a lady with a pleasing countenance and old style dress. Staff and customers have also observed this ghost wandering around the building on numerous occasions.

A lady went to her friend's wedding at Norton Parish Church and while waiting for the bridal party to arrive took some photographs. When they were developed they showed the image of a bridesmaid in Edwardian costume. The lady wrote to Kodak who said that the bridesmaid was familiar to them, she had appeared on other photographs taken at Norton church.

There's a possibility that in October 1989 when a man from Batemoor took a photograph looking across Graves Park Lake which is near the church, he captured the same lady. When the photograph was processed it had an unexplainable mark in the centre. He made an enlargement and found what he described as a girl in a long, white, heavily flounced bridal dress, holding a bunch of flowers. When he took the photo he would have noticed if such a person was in his shot. It was a bitterly cold day and he was wearing his thick anorak yet her dress was short sleeved.

Having seen the enlarged photograph which is so blurred it is difficult to recognise even a tree, I'm inclined to think he's got a good imagination.

Often these photographs show a white wispy substance out of which the face is starting to appear. In recent years the white wispy form has appeared more and more, often without the attendant face. These are often described as vortex pictures, as a faint helix form can often be detected within the white cloud.

It was mid afternoon when I went for a walk round Castleton graveyard and experienced one of my scariest moments. I was looking for a good angle to take a photograph of Peveril Castle perched on the hill, with a few gravestones in the foreground for effect. There was no one around and I'd just taken a few shots when just behind me I heard a clink, clank sound like clashing chains. I whirled round but saw nothing, although I'm not too sure what I expected to see; perhaps some fettered phantom Jacob Marley style.

Castleton graveyard where a white misty shape floats in the branches of the tree on the left – can you see the features of a face?

Rasping with relief, I'd almost decided to file this under incidents with no logical explanation when it sounded again and my eyes shot to the flagpole. I walked over, eyes fixed. I plucked the rope and as it twanged back and hit the metallic flagpole the sound was repeated exactly. I'd physically had to pluck the rope, so what had happened earlier? There was no-one else in the vicinity, no wind, and no explanation until I looked at one of my photographs later, and there, floating over a gravestone was a white misty shape. As I looked closer, I realised I could see a definite face. It had dark features, a heavy jaw or ruff, receding hairline and prominent ears. Was this a phantom who had summoned up all it's power to make contact?

Seeing is not Necessarily Believing

Many apparitions that are captured on camera are not seen at the time the photograph was taken. We still have no clear idea how the phenomena works although many researchers claim that such images are of spirit energies trying to get through to us. On the other hand, the sceptics claim that such marks can be explained as the accidental intrusion of jewellery in front of the lens, flaws on the film, double exposures, flaws in developing or tricks of the light. With many moving parts to the lens system this could distort images or small particles of dust, raindrops or moisture can be illuminated to create out of focus blobs that are assumed to be supernatural.

St Anselm's school at Bakewell was founded in 1888 on its present 18 acre site. The main buildings are accessed off Stanage Road, but our story relates to a photograph taken in the gardens where a garden-party was taking place. One of the masters was taking photographs to record the occasion, and when the photographs were processed (pre-digital days) one group standing on the garden steps had been joined by another figure, a boy in Victorian dress.

When I gave a talk at Bolsover Library in February 2010, a lady told us about an extra that appeared on a photograph taken at her Bolsover home. Her daughter and friends posed for the photograph with a very fretful younger member of the family who is crying in the photograph. When the photograph was processed, by the side of the girl and in front of the legs of one of the women was the image of another child – a ghost child. Who she was and why she should appear is a complete mystery. Could the human child have seen or sensed the ghostly presence which might account for the fractious tears?

I was completely unaware that in 2004, I had captured an image on camera at Elvaston Castle on the outskirts of Derby. The photograph was taken to show the different brickwork that indicated a later addition to the Castle, and also the window where a ghostly image of a lady in white is regularly reported. I'd researched the history of the building, talked to the staff and discovered a good story which related back to Maria Foote, Countess of Harrington, actress wife of the 4th Earl of Harrington, shunned by society and kept a recluse at Elvaston. She was undoubtedly the ghostly white lady that glides between the castle and the churchyard and unbeknown to me as

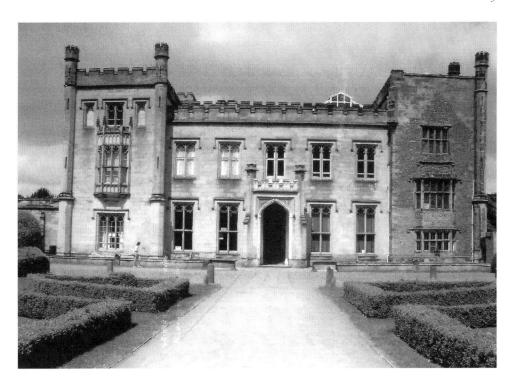

Is this the ghost of Elvaston Castle caught on camera?

I took the photograph, I was standing right in the middle of her flight-path. I took the digital photograph on an automatic setting on a bright sunny afternoon and the image looked perfectly normal. By the time I wanted to use it my printer was acting awkward and the quality of the prints were very weak. It was when I darkened the image to over-compensate for the problem that I noticed the white lines. My first reaction was that the emulsion had been scraped off the print. I examined it in all lights and under a magnifying glass but the surface was unblemished. I blew up the image to see the white lines more clearly and then it suddenly struck me that the white lines, almost undetectable in the sunny photograph were exactly where and what one would expect if I'd caught the ghost of a white lady walking towards me on that path.

One of my most surprising photographs was taken recently in Wingerworth graveyard. Gwen White had told me how she and her husband accompanied by their border collie dog Sammy were walking through Wingerworth graveyard one evening when suddenly a figure swelled up in front of them before disappearing into a yew tree. Sammy who had been charging around, stopped stock still with his ears pricked up, staring at the spot.

'Did you see that?' asked David in disbelief.

'I did,' replied Gwen and was able to describe the phantom as a man wearing black trousers and a white shirt with sleeved rolled up to his elbows although unnervingly, he was semi-transparent.

Have I photographed the ghost of Wingerworth graveyard?

Have I captured that same figure?

The sceptics are still searching for a valid reason to denounce it, but one thing is for sure, this new wave of spirit photography is here to stay, until such time as it can be explained one way or another.

HAVE A GO

According to statistics, one in twelve people can sense a non physical presence, so if you have a natural clairsentience for detecting unseen presences and feel there is a presence on the site, take a photograph. If you are experiencing any form of auditory phenomena like ghostly music, tapping, sighs or laughter, it might be acoustics, but use a voice recorder and take a few photographs just to see.

That's what I did at Wingerworth Hall which dates back to 1670. Using a standard 35 millimetre, single lens reflex camera (pre-digital days) I captured several mysterious green orbs, both inside and out.

That's what Ray Pearson the late founder and principle of the Chesterfield Paranormal Research Bureau did at a house just outside Chesterfield. Ray had been asked to investigate the strange phenomena that was causing a lot of concern for the householder. One of the problems was a definite cold spot. When the lady sat there, she began to shiver, her hands grew icy cold and goose pimples appeared all over her arms and legs. As she demonstrated this, Ray and his team watched in amazement as a small green ball of mist began to form in her hand. Ray grabbed his camera and took a few hurried shots before it dissolved, but when the photographs were processed all he had were a pile of shots of the lady's empty hand.

Are Orbs Captured on Digital Cameras the First Manifestation of a Ghost?
At the end of the twentieth century a new phenomenon in spirit photography seemed to coincide with the introduction of digital photography techniques. Now it is possible to take a photograph and see the result instantly, and it is also easy to print the images using your own computer rather than sending a film to a lab to be processed.

But it wasn't long before people started reporting that strange light anomalies, mostly spherical, were being caught on camera, so what are these spherical shapes that appear when using a digital camera? Are they specks of dust perhaps trapped on the lens, or minute particles of metal suspended in the atmosphere of a room? Could these specks reflect light in such a way as to appear like an orb of light? That's what the cynics would have us believe, but stories soon began to circulate that these orbs are the captured images of spirits, so have we at last been able to obtain images of the dead because we are using ever increasing sensitive technology? What if orbs really are the first manifestation of a ghost?

The fifteenth-century Crispin Inn in Ashover is believed to house seventeen ghosts including monks, cavaliers, itinerants, animals, former landlords and children.

Green orbs captured at Wingerworth Hall
– to the left of the first floor window and
in the kitchen prior to its revamp

The dining room at the Crispin is spiritually active but is the orb I have captured one of the spirit entities?

Early records of The Crispin, show that it was the residence of the Wall family, shoemakers and publicans, and an apt reason for the inn's name. St Crispin is the patron saint of cobblers, saddlers and harness makers, the main occupation of most of the men of the village centuries ago.

in July 2004 the Crispin was taken over by new owners who almost immediately set about architectural surgery. Retaining its authentic ambience, they not only achieved a transformation sympathetic to the building, they also disturbed the ghosts.

Workmen were regularly traumatised and admitted that they regularly felt something or someone behind them giving them a push. Customers since have felt strange sensations and on one occasion, the background music suddenly blurted out at full volume. No one had been near the music centre, yet the knob had been turned to maximum. Customers report feeling a drop in temperature or a cold draught often referred to as a psychic breeze. It is believed that heat is converted into metaphysical energy that causes manifestation or supernatural activity to take place. While dining at the Crispin I have experienced this although no one else at the table did. I also felt the sensation of an animal rubbing against the back of my legs although looking down there was nothing to be seen. I took a photograph of the empty dining room and discovered that I'd captured a large spherical light on the back wall. My first reaction was reflection from the wall lights, so I took another from exactly the same place a few seconds later, but the orb was not repeated.

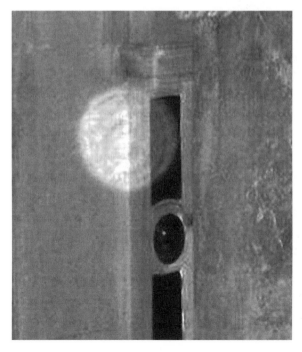

This page: The fireplace in the Elysium room where a visitor felt herself being pushed towards the heat of the fire where I captured a giant orb

Bolsover Castle is literally pulsating with spirit life and the staff keep a book in which they record any form of paranormal activity experienced by visitors or staff. They have very willingly allowed me to read the book and it does make very interesting reading. All around the castle, people have reported being spoken to, pushed, slapped, tickled, pinched or their clothing tugged in a childish or familiar way. In the Little Castle, visitors smell perfume and pipe tobacco particularly in and around the Elysium room. One lady wrote in the book that she felt pressure on her back pushing her towards the fireplace in the Elysium Room and she even felt the heat from an invisible fire. I took a photograph of that fireplace and discovered a huge orb on the stone upright over on the left.

The Camcorder Ghosts
People claim to have captured ghosts on video cameras and camcorders

Residents of a block of flats in Clay Cross park their cars on the neighbouring street, but one particular resident's car alarm was repeatedly activated in the middle of the night, causing him and his neighbours many sleepless nights. From his bedroom window he could see his car, yet looking out after the alarm was activated there was never any sign of anyone in the neighbourhood. This could only mean one of two things, a faulty alarm or someone who was getting away extremely quickly. He reasoned that if it was a faulty alarm it would happen at other times – which it didn't, so to rule out the fleet footed intruder, he rigged up his camcorder and left it running overnight in the hope of capturing the culprit. The alarm duly sounded, and as usual he shot out of bed too late to see anyone. But when he examined the camcorder footage, he couldn't believe his eyes. A ghostly shape was hovering round the car and disappeared immediately the alarm sounded.

Liam Stone sent me a section of camcorder recording he had taken at Shirebrook graveyard. He admitted that he and a friend had been watching a late night horror movie and decided to visit the graveyard as a dare. Liam had taken his camcorder and was panning round the deserted graveyard when he saw a strange, curving light rising from a grave. It formed a definite shape He was able to capture this on his camcorder and has since spent considerable time trying to decipher what this unconventional symbol could possibly have been.

When engineers were called to Tissington Hall recently to do a survey, they filmed video footage in what has become known as the haunted bedroom. On one section of the film, a full length portrait was seen falling to the floor, yet there was no such portrait in the room at the time. Had the video footage somehow 'seen' the room as it once had been, like looking at a sort of hologram?

The Theatre Ghost Captured on a Security Camera
Keeping up with technological progression, many buildings are now covered by security cameras that work rather like static, wall or ceiling mounted camcorders to record specific areas.

When they moved the box office, one such security system was installed at the Pomegranate Theatre, Chesterfield which is part of the Stephenson's Memorial Hall, Like many Victorian buildings, The Pomegranate has its fair share of ghostly happenings experienced by management, actors, caretakers, stage-hands and technicians. Noises and footsteps have been heard in the upper part of the theatre when staff were certain the building was empty. Mick was stocking the upstairs kiosk which they use when catering for a busy productions when a man in full tail coat and a stove hat walked past him. He dropped the tray and ran. There have been several other eerie sightings of this elderly gentleman in a black coat and stove-pipe hat, believed by many to be the great George Stephenson himself. George Stephenson the railway engineer spent the last ten years of his life in Chesterfield, and after his death, the Stephenson Memorial Hall, erected on part of the graveyard of the Crooked Spire was built in his honour. Another spirit visitor is believed to be an old actor, a man known for his love of pipe-smoking, because a distinctive feature of the hauntings is the sweet, lingering aroma of tobacco.

A caretaker was busy cleaning the floor one day when the heavy doors, the only access to the room, suddenly burst open. The force and shock of this phenomenon left him understandably shaken and his terror increased just minutes later when he heard footsteps descending to the lower part of the building. Staff regularly hear the electric hand dryers in the toilet block working although no one is in there. Technicians have heard seats banging of their own accord, and there are two particular rows in the theatre where you can feel a very cold sensation as you walk along them.

Although most of the activities take place when the theatre is almost empty, there are a number of exceptions. Theatre goers have told how seats in the auditorium mysteriously move down from their upright position. During one production when the theatre was virtually full, Sue, the front of house lady watched a man leave his seat, move across the front of the stage and disappear.

This is the area where a security camera picked up a strange nebulous shape. The camera was pointing towards the back of the stage which was empty, but in the booking office where the viewing apparatus is installed, the staff watched a cloud-like mass move across the screen. They looked for the most obvious reason for such an abnormality but eventually had to admit they had captured a ghost on their security tape, so next time you go to the theatre, watch out because as they say in the best pantomime tradition – 'It's behind you!'

The Pub Ghost Captured on CCTV

Julie Birch, Manager of the Ace of Clubs, a former miners' welfare club at Bolsover was locking up one evening when a movement on the CCTV screen set her heart racing.

'I didn't know what it was, but it seemed to be running across the back room from the kitchen,' said Julie. 'I was so scared I got out as soon as I could.'

When Julie told her friends no one believed her until they saw the footage which shows an orb-like orange ball speeding across the building.

'There have also been times when something has just flown off the side or fallen off the wall randomly,' said Julie. ' If this is some elusive visitor it would appear that he has

A photograph of my aura

a penchant for real ale, as I've also snapped a spooky figure lurking behind the taps. It's possible to make out a face hovering behind the bar, but it's all rather a mystery.'

Kirlian Photography
For centuries people with paranormal abilities have claimed to be able to see auras, the electromagnetic energy field produced by and surrounding the body, but in 1939 a Russian scientist Semyon Davidovich Kirlian and his wife Valentina invented a way of photographing that aura. They called it Kirlian photography. All living things have an aura which is egg shaped and extends for some distance beyond the body. It has a variety of colours which reflect the spiritual, emotional and physical state of the person, and although one colour usually predominates, the aura varies in colour, density, clarity and size according to changes in the subject's mood or health.

Now computer software is available which can photograph the aura and provide the subject with an interpretation of its shape, colours and features as my aura photograph shows.

Taking this one step further, is it possible that the strange, often coloured orbs of light caught on digital camera could be auras of the deceased? The sceptic might say that Kirlian photography records the aura of a living thing, but tests have shown that images can be produced from things that were once living, so why not spirits?

We may not be able to see their image, but does their aura remain? Could this be some kind of blueprint that can be built up in the same way as DNA to produce an actual image and identify a dead person. It's an intriguing thought which one day may become a reality.

Can We Actually
Communicate with Spirits?

Curiosity about ghosts and other paranormal phenomena has brought about inspired attempts to establish or explain whether life in some form does exist after death, and if it does, can it be contacted? Because we believe that ghosts can be seen, we have looked at a few rather inconclusive photos of ghosts caught on camera. In the same way, if ghosts can be heard, is it possible that the sound can be captured on some kind of recording device? The term Instrumental Transcommunication or ITC covers spirit communication through all manner of electronic equipment including radios, telephones, television sets and even computers. There have been incidents where the face of the deceased has been seen and positively identified breaking through a regular broadcast on a television screen, but the more common forms of ITC are indistinct, disembodied voices. It's not unusual to find that people report hearing strange voices that sound hollow and inhuman on answering machines. It's generally impossible to state with any accuracy what they are saying due to distortion, yet with technological progression of recording equipment it's probably only a matter of time.

Electronic Voice Phenomema or EVP
In the 1920's Thomas Edison the prolific American inventor of the electric light, the phonograph, the microphone and the kinetoscope (a forerunner of the movie projector), to name but a few of his inventions, admitted to working on a device for contacting the dead.

He told *Scientific American* magazine that he believed it was perfectly possible – *'to construct an apparatus which will be so delicate that if there are personalities in another existence or sphere, this apparatus will at least give them a better opportunity to express themselves than the tilting tables, raps, ouija boards and other crude methods now purported to be the only means of communication.'* Unfortunately Thomas Edison passed over before he could build the apparatus.

Little more was done in this field until 1959 when the Latvian born Swedish singer, painter and film producer Friedrich Jurgenson made a recording of a nocturnal bird song. When he played the recording back, he heard a voice although no-one had been

present. At the time he thought he had inadvertently picked up a radio broadcast, but later he recognised the voice of his deceased mother speaking directly to him. Jurgenson went on the make hundred of recordings and in 1964 published his findings in *Voices From the Universe*. Over the past four decades, thousands of alleged voices have been recorded in experiments in Europe and the USA. Messages are invariably short, nonsensical or banal in content although occasionally researchers have reported receiving lucid and coherent statements in response to spoken questions.

During the 1970s while carrying out research into Electronic Voice Phenomena or EVP, George W. Meek and William J. O'Neil claimed to have invented a machine which enabled them direct communication with the dead. From 1972-1982 they made five different Spiricoms – short for spirit communication machines – capable of producing voices that had a monotonal electronic sound to them, with no pauses for breathing. The project was abandoned in 1982 but others like Otto Koenig's Generator, and Klaus Schrieber's Vidicom have since expanded and improved on the principle.

If you want to experiment with EVP all you need is a digital recording device such as a mini-disc and an analogue radio. Cassette recorders are not suitable as they produce excessive hiss at low volume, and mechanical noise which can cloak the signal. Tune the radio to a frequency between stations so that only a background of static or white noise is audible for the voices to print through. It helps if you foster a healthy scepticism as you listen carefully to your recordings at different speeds, or when you are analysing your results you are at risk of reading something significant into what is really only random interference like 'print through' from previous recordings, digital 'artefacts' and signals bleeding from adjacent stations. The potential for misinterpretation is so common, that a medical term 'auditory pareidolia' has been coined to describe it.

It is also possible to purchase an ultra sonic unit which measures acoustic energies in ultrasound regions at frequencies of 20khz and above. This is the range of sound that dogs can hear but is beyond human hearing. It's a known fact that animals, particularly dogs, are sensitive to lots of things that we are unable to see, hear or sense, so an ultra sonic unit might take us part way to understanding the strange ability that they have.

Psychokinesis or Mind Over Matter
There have always been shamans, seers and psychically gifted people who claim or believe they are able to make contact with the dead. They have an innate ability to see something the rest of us can't detect. It's a gift in the same way as someone who has the God-given talent to play a piano without music. At least that's what we've always believed, but now more and more of us are realising that we can tap into some hidden power and establish our own form of communication with another mode of existence by using our own psychic ability – abbreviated to PSI.

In Chapter One, we've looked at the way our five senses work and the probability of there being a sixth sense. Taking this one step further we arrive at Psychokinesis or PK, the reported ability to influence other people, objects or events by act of will and not involving any known physical force or intervention. In other words, we are using just the power of the mind. Psychokinesis is based on the principle that no action is accidental or random, and that by using mind power we can influence the outcome.

Think Uri Geller and those bending spoons! (Did you read about his germinating seeds in the introduction?) He brought to our attention the fact that by using mind power, it is possible to influence the molecular structure of metal in a manner not reproducible by any other means. Numerous other people then discovered they too could do that and it became a bit of a party trick; not very practical when you're eating a bowl of soup.

Uri Geller told people to take any broken clocks and watches, and concentrate on making them work using only PK or the power of the mind. It was also alleged that he could stop clocks too, and famously claimed that when Big Ben, the massive clock in the London Houses of Parliament stopped in 1991, it was the power of his mind that had stopped it.

Parapsychologists believe that we all have the power of psychokinesis but don't realise it. Apparently we don't trust the automatic radar that operates in our unconscious mind. If that is correct and we have this invisible power and secret knowledge, can we stop and start clocks at random? I decided to find out.

It might be just a fluke, but a watch that I've had for years has never worked reliably and has been 'repaired' at least three times by different watchmakers without success. After giving it a good talking to, (and feeling ridiculous for doing so) it's now working perfectly.

Andy Threatened the Clock

A wall clock in the hall at the Crispin Inn, Ashover stopped working on the Friday. Thinking it might have got moved or knocked slightly Andy the proprietor tried nudging it gently back in line. It started to tick but after a few minutes stopped again. He tried again and it went for a few minutes then stopped. Later he tried again, but without success. Next day he tried yet again and got the same results so telling the clock that it was only fit for fire wood, he left it. Next morning when he went downstairs he passed the clock and not only was it going, it was at exactly the correct time. Andy was initially rather surprised but reasoned that it was obviously his wife who had managed to get it to go and set it to the correct time. When he saw her, he commented on this.

'I never touched it,' she exclaimed in surprise. 'I thought you must have managed to get it to go.'

There was no one else in the building who could have sorted out the clock, so the situation remains a mystery particularly the fact that the clock has continued to work and is still at the correct time, so was it a fluke, spirit intervention or psychokinesis?

The Clock Stopped at 9.30

Many people experience clocks stopping or chiming at irregular times. A well respected watch and clock repairer told me about a call he made to sort out the grandfather clock of a lady who lives in Bakewell. He could find nothing wrong with the clock and recommended that in future she wound it regularly to prevent it stopping. Common sense you may think! So why did she need to call in the repairer to tell her that? Apparently, her husband had always wound the clock and since his death, despite the fact that she wound it regularly, it was the freaky fact that the clock continued to stop and it was always at 9.30 p.m. the time at which her husband died.

The Clock Struck 12
One family had a grandfather clock which accurately supplied the normal horological information, provided details of the current phases of the moon and days of the year. The clock had been handed down in the family for several generations and had always been a reliable time-piece, so one evening at 8.30 p.m when it struck twelve, they took note. At 9.00 p.m it struck nine and from then on continued to work accurately and to the regular pattern, so they concluded that this was obviously due to some minor mechanical defect. Shortly afterwards, they received news that an aged aunt that as a child was brought up in the same house as the clock, had died at precisely 8.30 p.m.

He's Fiddled with the Clock Again
Many old cottages have a resident ghost, and householders are usually unaware unless something specific happens to alert their suspicions.

A lady was staying with friends in Bonsall and next morning when she went down for breakfast she was amazed that it was so late.

'Have you slept well?' her hostess enquired.

'Yes, but I had no idea it was so late,' she said glancing at the kitchen clock. 'I'm sure the bedside clock in my room is an hour earlier.'

Her hostess laughed. 'It probably is. We have a ghost who likes playing with clocks. We often find them stopped or not telling the correct time.'

Clocks are usually decorative; they can be temperamental, but most of all they need to be functional so if your clock is misbehaving, take note. There's no guarantee that some kind of spirit interference is at work, but next time your clock stops, try starting it using psychokinesis.

Apart from clocks, it is actually possible that other inanimate objects can be subject to some form of mind control that we are capable of administering knowingly or otherwise.

Poltergeist Activity
Many phenomena previously accredited to ghosts or spirits of the dead actually have their roots in psychokinesis and the most well documented is poltergeist activity which is usually but not always centred around one particular person and only happens when that person is present.

Poltergeist means 'noisy ghost' in German, which is an apt description as the phenomenon is often accompanied by sounds of smashing, banging, scraping or dragging. Poltergeist activity is unseen energy that is able to move objects, create sounds and smells.

Having a Smashing Time
At Bleaklow Farm on Longstone Edge, Mr F. A. Radford and his brother were watching the late night movie on TV when suddenly there was a loud crash as the clock which stood on top of the china cabinet fell over. As they watched in stunned disbelief all

the objects in the china cabinet began to fall over as if pushed by an invisible hand. Of one accord the two terrified brothers ran from the room. It took some time before they dared to re-enter the room where they knew they would have to deal with the inevitable chaos and breakages. They expected to see a cabinet full of broken china and more, but instead, the clock was ticking away in its customary place and all the objects in the cabinet were in their usual order. In stunned disbelief they opened the cabinet and reached for each object in turn. Nothing was broken and there was no sign of a chip or crack on anything.

Some years ago, a Birchover lady bought a picture of a horse and hung it over the fireplace in the sitting room, but next morning the picture was propped up against the opposite wall, its cord unbroken, and glass intact. She re-hung it and the same thing happened again. After much deliberation, she hung it on the adjacent wall but again, next morning the picture was propped up against the opposite wall, undamaged. She re-hung it, but the same thing happened again and again, until eventually she gave the picture away.

A year later another mysterious happening occurred at the same house. The eighteen year old daughter had begun collecting glass animals and birds which she displayed in a glass cabinet. Nothing strange occurred until she acquired a glass swan which she put in the glass cabinet with her other pieces, but it persistently refused to remain in its appointed position, and she often found the swan reversed with its back on display. She considered the possibility of vibration that might have gradually moved the swan but as it didn't affect any of the other ornaments in the display, that was discounted and the family never did find a satisfactory explanation.

They say things come in threes and the third incident at this house is by far the most bizarre.

The lady of the house was papering the bedroom situated on the left side of the stairs, and the bedroom door which led onto the landing was open. She was alone, standing on a step ladder attaching a length of wallpaper to the wall when suddenly something struck her in the middle of the back. Turning round, she looked down to see a light bulb on the floor, the only possible explanation for what had just hit her. The bulb was unbroken but what was most surprising was that it was the bulb from the hanging pendant light on the landing. By some means it had become detached and fallen, but instead of tumbling directly down the stairs, it had somehow defied the laws of gravity to swerve into the room and strike the decorator. When the bulb was replaced in the socket, it lit immediately so the delicate filament was surprisingly undamaged by its unusual journey.

Some poltergeist outbursts act almost like psychic temper tantrums. A teenage child or a person in an odd state of mind (depression, emotional outbursts and fits of temper) within a location that has a powerful energy field is usually found to be at the root of the problem, and as the state of mind changes, the problems usually cease.

Spiritualism and Spirit Rapping
In 1848, the Fox family were living in a small house in Hydesville, New York. It already had a reputation for being haunted when they moved in, and before long, twelve year

Tissington Hall where the team had a creaking floorboard conversation

old Margaret and ten year old Kate began communicating with the resident spirit entity, using what has become known as spirit rapping.

Initially a method was used in which the number of taps corresponded with the position of the appropriate letter in the alphabet, so communication was actually spelt out. This gave way to the much parodied code of one knock for yes and two for no. Stories of Margaret and Kate's abilities spread and they started to hold public demonstrations. While others had claimed to be able to contact the dead, the Fox sisters were the first to claim a direct two way communication with the 'other side', and to be seen and heard to be doing so.

Spiritualism was born as a direct result, and although it had an enormous following, people began looking for ways of exposing the methods used. This wasn't helped when in 1888, the Fox sisters admitted that they had obtained their spirit rappings fraudulently by cracking their toe joints. Spiritualism had suffered a severe blow but it was quick to recover.

A Creaking Floor-board Conversation

Tissington Hall is a private residence in the delightful village of the same name just north of Ashbourne. Escorted tours are available at certain times, but over Hallowe'en 2009, the present Baronet, Sir Richard FitzHerbert played host to two 'ghost evenings' at the hall. These were overnight vigils in selected spots around the house and on both occasions various 'sightings' and strange instances occurred. Sir Richard attended one of the vigils when the group believed they were contacted by one of his ancestors through a continuous 'creaking floorboard' conversation. Sir Richard said:- 'In fact we were so accurate with our dating that we can confirm that this character lived here in

the 1750s but, to find out more, you will have to register on another of our paranormal evenings.' To take up the challenge visit www.tissingtonhall.co.uk.

Automatic or Spirit Writing

Spirit writing can refer to two specific forms of writing – one that appears without the involvement of a living person, and another that is more often called automatic writing produced by a living person guided by spirit or psychokinesis.

If you wish to try automatic writing, sit quietly in a room holding a pen or pencil lightly over a sheet of paper. Relax and empty your mind completely, then your hand may or may not begin to write of its own accord. It is believed that this is a type of psychokinesis at work, a method of reaching the unconscious mind and hearing what it has to say. It might even produce legible writing, although most people find only meaningless scribbles on the paper.

Automatic writing took a bizarre turn in 1900 when one medium claimed to be receiving messages from dead Martians. As no-one was able to decipher the scribble who could argue?

Several people can combine their psychic talents in an attempt at automatic writing by using a device called a planchette. This is a small, flat board often triangular in shape, mounted on small wheels or castors which raise the board a few centimetres off the surface and allow it to move freely. There's a small hole in the board through which you push a pencil to stand in a vertical position. Place the planchette on a large sheet of paper, and adjust the pencil so that its point is touching the paper. The participants

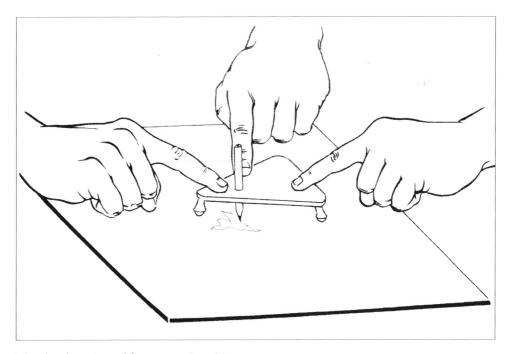

The planchette is used for automatic writing

should then each rest a finger very lightly on the board of the planchette, allowing it to move of its own accord over the paper.

In 2007, the team from Living TV's *Most Haunted* visited Tissington Hall, and discovered that the hall is bursting with spirit activity, some dating back to a time way before any building was there

On the ground floor, they picked up the spirits of a man and woman, heard unexplained noises, experienced temperature drops and saw a lamp move. When they moved upstairs, they found that the most spiritually active bedroom is number 4, and there David Wells the psychic and Yvette Fielding the presenter used a planchette board to produce automatic writing. They spelt out the letters W, L and O which was remarkably accurate because history has recorded the dreadful death of Wilhelmina who died here in a fire in 1862. She accidentally set fire to the bedclothes, her nightgown went up in flames and she ran around, wild with pain. Eventually her sister dowsed the flames and put out the fire, but Wilhelmina was dreadfully burnt. The fire happened on 20 August but she lingered on in excruciating pain until 15 September. Demented with pain, she felt that someone could have saved her if they had acted quicker, and her anger is so strong she now haunts the building.

Although a planchette is usually used for automatic writing, if you invert the pencil or replace it with a pointer it can be used on a ouija board.

The Ouija Board

A Ouija board, also known as a 'talking board' or 'spirit board' consists of a board upon which the letters of the alphabet and the words 'yes' and 'no' are written. The name is claimed to be a combination of oui and ja, the French and German words for yes. The earliest known patent for a OUIJA board was filed by Adolphus Theodore Wagner, a professor of music and resident of Berlin on 23 January 1854. He described his device as a '*Psychograph, or apparatus for Indicating persons thoughts by the agent of nervous electricity*'. Letters were placed on a table over which a pendulum would be swung to spell out the message.

This would confirm that the *psychograph* initially was believed to work through a type of psychokinesis and was a method of reaching the unconscious mind and hearing what it had to say, much as dreams are.

It was in 1861 that a Frenchman named Allan Kardec described it as '*rendering spirit communication independent of the medium's mind*', and suddenly using a Ouija board was like opening a door into the unknown. The pendulum was replaced by the planchette, and with the addition of yes, no and a few other relevant words, in the early twentieth century the Ouija board became a popular parlour game. It was seen as harmless fun, a mysterious and somewhat spooky leisure activity not to be taken too seriously. If the pointer did move, and if by some remote chance a word or message could be descrambled from the movements, each participant suspected the others of pushing or cheating at the very worst.

Of the huge amount of Ouija boards available today, some are sold as games, some are sold as specialist items for use in séances, but all seem to need a warning attachment

as the board has become known as a dangerous tool capable of opening portals and allowing demonic entities to enter our lives. Yet the board is just a prop and no more evil than a Monopoly board, so where did this idea come from?

We don't have to look further than such books and cult films as *The Exorcist*, *Witchboard*, and *The Craft*, all of which promote the idea that the Ouija board is a channel to evil forces, promoting serious negative experiences and horror stories that denounce the board. Most are sensational because that's the stuff people want to read about. The mundane doesn't get a mention.

In my experience, the participants drive the pointer in a random direction towards letters which usually spell out utter nonsense making it necessary to guess, edit and re-arrange in order to make any sense of them. Rather like a game of scrabble, the same letters can make a vastly different selection of words. For example if we had fourteen letters – STSADPSGHOREMA, we could make GHOSTS READ MAPS or SSG SHOT DEAR PAM; which one would you go for or can you make out others? Half the fun is in deciphering the messages, not interpreting them as evil premonitions that fill us with fear and trepidation because some entity with evil intent is about to enter our dimension to work some nefarious misdeed.

The manufacturers of ouija boards are well aware of this and are renaming their boards with names like 'Guiding Light Angel Boards', 'Angel Light Communication Board' and 'Angel Guidance Boards' to reflect the fact that they are not evil and do not attract demonic entities. Instead of the bad guys we apparently can now have the good guys guiding us.

It is more likely that any good or bad effects arise out of the energised subconscious of the users who unconsciously control the movement of the pointer. At least this is the theory that I work on. It's called the Automatism Theory or to use the clinical term – 'ideomotor response'. The Ouija board is a short cut from our own subconscious and when more than one person is operating the board it is called 'collective automatism'.

If you'd like to make a simple Ouija board, you'll need a smooth, polished table – a circular glass-topped coffee table is ideal. Write the twenty-six letters of the alphabet, yes, no and goodbye on separate pieces of paper and arrange them in a circle on the table. Turn a drinking glass upside down as a pointer and put it in the centre of the circle. As with the planchette, each participant rests a finger on the glass and it should move from letter to letter forming the words of a message. Keep it light. Try asking for winning lottery numbers and let me know if it works.

Psychokenesis Using Dowsing Rods
One customary way in which Psychokinesis operates is through divining rods, also known as dowsing rods, and pendulums which can have spectacular success.

Most of us don't trust psychokinesis or the automatic radar that operates in our unconscious mind, so the swing of the pendulum or rods gives an external and tangible expression of the psychic awareness we have hidden deep down in our intuition. This is transmitted through the body and into the rods or pendulum making them react by moving the muscles in our wrists. There is no scientific explanation for how it works but it does.

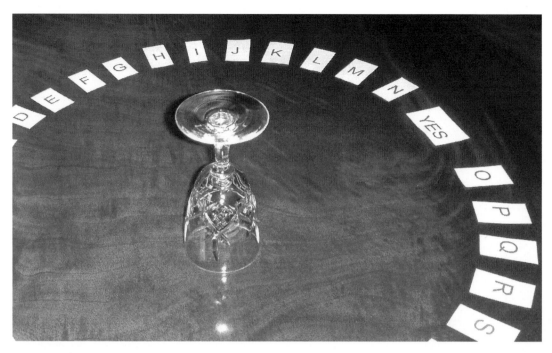

Make a simple Ouija board

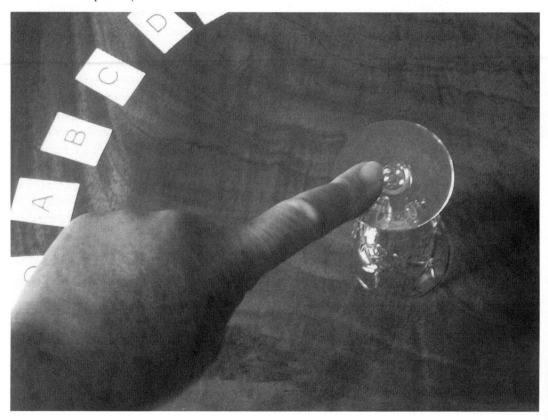

A custodian at Peveril Castle in Castleton used divining rods to track a ghost

Dowsing would appear to date back to at least 600 BC. A cave painting of that period found in the northern Sahara shows a man holding a forked stick just as a modern diviner would do. Certainly dowsers appear in ancient Egyptian, Chinese and Peruvian carvings. From the fifteenth to the seventeenth centuries, dowsers searched mainly for metal, and were often attached to the staff of prospecting and mining expeditions. In the eighteenth and nineteenth centuries, they looked mainly for water in arid areas. Through psychokinesis, divining rods are mysteriously able to pick up the electro-magnetic energy field of an object like underground pipes, tunnels, cables, ley lines, lost property, hidden treasure and archaeological sites. For centuries, Derbyshire miners used dowsing rods to find ore and it's used for locating oil and other mineral deposits. Today, dowsers are often employed by public corporations or in industry to pinpoint unmapped cables, pipelines and so on. Their services are also in demand by the FBI, CIA and numerous police forces because dowsing can not only summon up the secrets of the earth it can locate dead bodies and ghosts.

Yes, diving rods are quite capable of 'sensing' many things, including ghostly activity. A custodian at an English Heritage Property told me how she used divining rods to follow a spirit at Peveril Castle in Castleton. The rods spiralling movement in one corner of the ruined keep surprised her until a later check revealed a spiral staircase had previously been sited there. She is quite convinced that her rods had traced a ghost mounting the spiral staircase.

The ghostly occupants of Tissington Hall sent the divining rods and crystals used by one ghost hunting group quite ballistic. The Hall is known to have a number of ghostly residents including what have been described as a fun loving couple dating from the Civil War period. The lady is very elegant, the gentleman very authoritive, but there is a lot of laughter as they move through the ground floor rooms. So is it possible that they could have happily participated in the groups divining experiments in the snooker room? The group were certainly delighted to get such a positive response from their rods and crystals.

In the past it was probably in the professional dowsers own best interests to let people believe that his gift was extremely rare, but I'll let you into a secret; over 80% of us have the ability lying latent, and could with practice, become competent dowsers.

The Pendulum

A pendulum is simply a weight on a chain or cord. It can be made of any material, shape or size. You can use a pendant or medallion, a large needle on a thread, a key or a carved crystal. If you are searching for a specific substance, you can use a cavity pendulum that will hold a sample of the substance.

As long as the pendulum can swing freely and easily, the string or cord can be any length from a few inches to about 2ft (60cm). You may need to lengthen or shorten the cord to get a clear reaction.

Using a pendulum for divination is called radiesthesia, using a suspended key for divination is called cleidomancy, and using a suspended ring is dactylomancy. One of the traditional uses of dactylomancy is in detecting the sex of an unborn child. In this case, a pendulum is made by suspending the mother's wedding ring on a hair from her head and holding it over her abdomen. The pendulum will swing backwards and forward to indicate a boy and around in a circle to indicate a girl.

Indoor Dowsing or Radiesthesia

A pendulum can be used out of doors instead of using the more traditional diving rods but it is very susceptible to wind, and can only be used on a very calm day. For that reason it is best to use a pendulum indoors.

The pendulum should normally be held in your dominant hand. Hold the cord between your forefinger and thumb, and spread out your other fingers so that they are facing down, rather like a claw. The arm should be firmly braced but not held tense and your hand will be guided by your subconscious mind. You should find that you can use your pendulum to answer specific questions getting a 'yes' or 'no' answer.

At first it is worth asking obvious questions that you know the answers to, so that you can assess just how your pendulum reacts. It will respond by either oscillate a number of times or revolve in a clockwise or anticlockwise direction. It might swing from side to side or backwards and forwards, then by recording all the details of the gyrations of your pendulum under known conditions, you will be able to prepare your personal calibration chart for future reference.

If you want to use your pendulum to search for something on a map the smaller, more accurate pointer of the pendulum is ideal. Map dowsing is also known as remote

Metal divining rods are made with a metal coat hanger and the sleeves from two gel pens

dowsing or psychic archaeology. Hold the pendulum over the map and asks a question such as 'Is this the way to…?' or 'Is X here?' Cover your search area methodically, working very slowly across the map and marking any reactions you obtain. Your pendulum will spin wildly if it detects spirit activity.

I was taught to use a pendulum over six envelopes. Five were empty; one held a £1 note. Was it so long ago? If you want to try this I'm afraid it will now have to be a £5 note, and you'll need someone else to put the note in one of the envelopes. Holding the cord, pass the pendulum slowly over each envelope in turn, and you will feel a sudden heaviness as if pulled down by gravity over one choice. Soon you will get the feel for radiesthesia and be able to make the correct choice from a selection of possibilities with 99% certainty.

To Make Metal Divining Rods
If you decide to make metal divining rods, you will need a metal coat hanger – the type that come from some dry-cleaners, and two sleeves from ballpoint or gell ink pens. Cut the hook off the hanger, then divide and cut the metal rod into two equal pieces. Remove the inside of the pen, then thread the empty sleeve on one end of the metal rod and bend the metal into a right angle just above it. Straighten the metal and repeat with the other piece.

Walk forward holding the rods and watch them react

When using your metal diving rods, hold one in each loosely clenched fist with your thumbs resting over your forefingers. Your forearms and the arms of the rods should be horizontal and parallel to each other, and your elbows should be tucked in. Raise your arms to the level where the rods face straight out in front. If your arms are raised too high the rods will swing away from or against your body, but once balanced, simply hold the divining rods and walk slowly forward. You'll look rather like a wild-west cowboy about to fire his guns.

Now concentrate your mind on what you are looking for. Some dowsers find it helpful to carry a sample with them. The sample should be small enough to carry comfortably, but large enough to be in contact with. Liquid should be carried in a small bottle. A photograph, a sketch or personal item can be used; anything that helps you concentrate on what you are searching for.

Walk slowly and steadily over your search area, taking short strides so that you cover the area methodically. When your rods react, use markers to indicate the places. The reaction will vary. Your rods will either cross or swing apart.

When searching for spirits, stand in an open space, and simply ask if there are any spirits around. The wand will swing to the right for yes or left for no. If the answer is yes, the rod will point in the direction of the spirit and will actually trace

it. Upon reaching an area of spirit activity, the rods will begin to swing wildly and cross over each other. At first the reactions you obtain may be weak, but they should become stronger with practice. With experience, you'll find that it is possible to tell from the strength and nature of the reaction exactly what you have found.

Like in many things, in Psychokinesis, patience, concentration and belief is needed.

GHOST HUNTING

So are you ready for a spot of ghost hunting? It's great to visit places in daylight but at night they take on a very different character, therefore before planning a midnight investigation, it's wise to familiarise yourself with the location and possible hazards during daylight hours. Make sure you are not trespassing on private property and if other people may be affected, show consideration and explain what you are doing before hand. Be prepared, be sensible and play safe. If you get into difficulty through stupidity this reflects badly on all of us.

Carry the basic equipment.

Take a torch – old buildings and graveyards don't have electric lights.

Carry a note pad and pencil or a compact personal recorder for recording those precious moments you think you will never forget but do.

If you are investigating with a colleague or are splitting into teams, have a set of two-way radios so that you can communicate.

Digital cameras are compact and precise – great for recording ghosts. Digital phones are useful in an emergency and can also double as cameras.

An added extra is a camcorder with night vision, a built in light and a microphone. And make sure you have plenty of tapes and spare batteries as ghosts will mysteriously drain energy from batteries. A tripod is a bonus, so that you can set up your camera and leave it in an 'empty' room.

As you get more serious you might like to invest in an EMF meter which detects the electromagnetic fields often associated with ghosts and paranormal activity. It also picks up electrical appliances like televisions, digital alarm clocks, power lines etc. It can't differentiate so you will have to. Before using it for ghost hunting, practice at home; see what readings you get from your TV set and see how far the electromagnetic field extends away from the set itself.

When scanning for ghosts, examine headstones, chairs, couches and other sitting surfaces. Scan corners and closets and anywhere you think a ghost might be. Don't just point it; move the meter up, down and across an area.

If you don't have an EMF meter, use a compass which will detect magnetic fields. A ghostly anomaly will usually tilt the needle at least 30 degrees off magnetic north, but as previously stated, make sure to rule out other forms of electrical energy.

Use a digital voice recorder, and place it in an area where haunting activity is suspected. If using analogue equipment, try and use a recording device that has a microphone separate from the case. Microphones that are in-frame tend to record

Are you ready for a spot
of ghost hunting?

noises that are generated from internal motors and turning wheels, so a detached microphone will significantly minimise this type of unwanted noise.

If you intend to take temperature readings at an investigation, carry an infrared thermometer so that you will be able to accurately record sudden, unexpected and short lived drops in temperature. A Hanwell Monitor records changes in temperature and humidity. A more expensive alternative is an infra-red laser scanner, a point and shoot device that detects temperature differences using infra-red technology.

Motion sensors also work on infra-red. Leave one in an area you think might be active and it will alert you if it detects any movement.

In a location where things are going missing or being moved on a regular basis, try planting a few trigger objects. Place a sheet of white paper on a surface, put an object on the paper and draw round it. Leave it for as long as possible then return to see if the object has moved.

There's a theory known as 'Standing Wave' that tells us that in certain conditions extractor fans in rooms, corridors and even in computers can give off an odd acoustic effect that creates the impression of something moving fleetingly at the very edge of our vision, so be aware of this.

If you have the feeling that someone or thing is present but there is no visible evidence and no way of proving it, speak out loud; greet the presence. Just hearing your own voice helps put you in control and reduces the feeling of dread. After all it could just be old Sam coming back to see what improvements have been made to the old place. Please don't scream too loudly – you might frighten him away!